ON
TOUR
WITH
LEONARD
COHEN

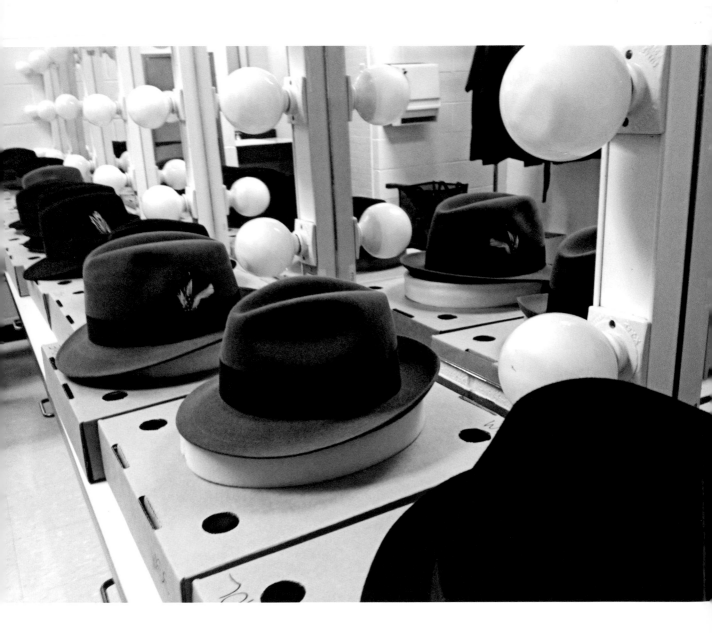

ON TOUR WITH LEONARD COHEN

photographs
by
Sharon Robinson

essay
by
Larry "Ratso" Sloman

powerHouse Books

Brooklyn, NY

"AN EYE AS FINE AS HER EAR..."

-Leonard Cohen

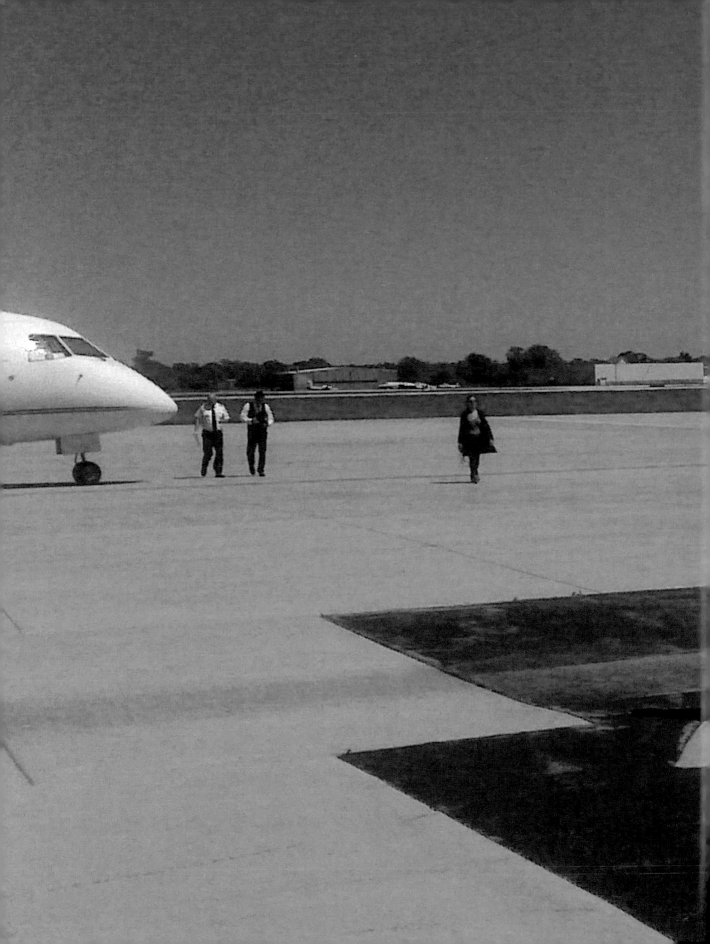

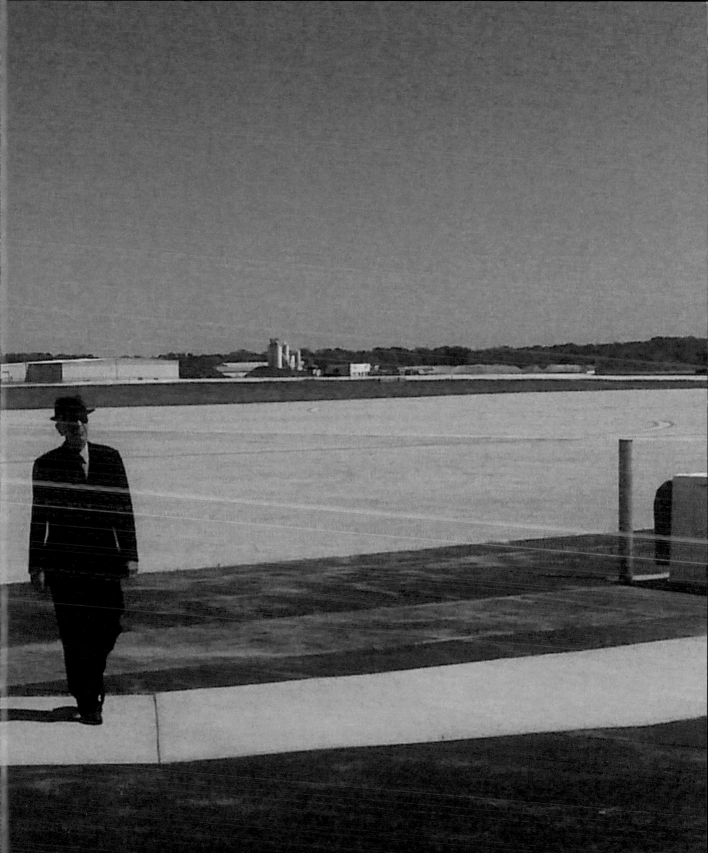

ON THE ROAD WITH LEONARD

by
Larry *"Ratso"* Sloman

The first time I met Leonard he was in his hotel room in midtown Manhattan, moaning. It was late November 1974 and he was in New York to perform at the Bottom Line. Performing in New York always made him anxious but he was particularly stressed by his record label's decision to censor the cover of his new album, *New Skin for the Old Ceremony*. I was a cub reporter from *Rolling Stone* magazine witnessing his dismay.

"Look at this," he said, handing me a mock-up of the cover of the U.S. release. In Europe, the album had already sold mucho copies with a beautiful image of two naked but crowned figures in a sexual embrace taken from the alchemical text *Rosarium philosophorum*, an image popularized by Carl Jung. Thinking the image was too racy for U.S. record outlets, Columbia Records had substituted a photo of Leonard that looked like a cross between William Burroughs and Soupy Sales. To make matters worse, Columbia hadn't even responded to Cohen's telegram of protest.

"Every critic attacks me for being so depressing and Columbia highlights that in an ad. Wonderful!" he said. It was true. In the ad copy for the album, Leonard was called a "chronicler of despair."

Now he started pacing the room more frantically.

"Is this the style of American business practices today? Is there any honor left? I'm appalled at the whole feminization of the scene. There's just a collapse of manly virtue and we're going to pay for it. As soon as America is weak, there'll be others to carve it up, both from the interior and the exterior."

I'd never met Leonard before but I wanted to give him a hug, tell him it was all going to be okay. But all I could manage was, "Isn't it good that men are becoming more in touch with their feminine side, their emotions?"

Leonard stopped pacing and plopped wearily on the sofa. He gazed out the window. The view was of another high-rise building.

"Look, I don't want to make a big point of this honor business because it puts you in a certain camp," he began. "Every fascist that comes along makes a point of these virtues and uses them as an opportunity to inflict his power and vision on susceptible people. But you also get tired of getting kicked around by the latest guru and the latest revolutionary hero. You're trying to get out of pain and there are various invitations all around. One says meditate. One says shoot heroin. One says sleep with a lot of girls. One says sleep with a lot of boys. There are a host of invitations, but because of the way the world is constituted, at least 99 percent of them are hustles. Maybe I'm a little tougher. I'm in training now and the rigors of the road dictate a certain lifestyle. I've had my share of being taken."

The next night, the Bottom Line was filled with kindred spirits, survivors of those hustles. Leonard, in a grey suit and an open-collared black shirt, fought off a hoarse voice and regaled the crowd with his songs of love and hate. And they loved it. As soon as the set was over, Leonard retreated to the small dressing room and collapsed on the couch.

"My knees were shaking," he confessed to his manager. "But this is a good place to be nervous at."

I remarked on the amazing reverence that the audience had shown him.

"People are interested not just in my own experience but in the experience of anybody who has come through without committing suicide or going into a loony bin. You know, there is some interest in survival," he said.

By the next night, Leonard was considerably looser. Earlier that day, Columbia had compromised and agreed to issue the record with the original drawing augmented by a little modesty wrapper covering the offending genitalia. Judy Collins had dropped by to say hello. It was two a.m. and the band had just finished their fourth encore and the crowd was still crying for more.

In the dressing room, Leonard was like a manic general.

"C'mon, let's give them some more," he barked. His entreaties ceased only when the house manager, seeing visions of a five a.m. closing, turned up the house lights.

Leonard wandered over to a platter of cold chicken and grabbed a wing. The sweat pouring off him mirrored the raging rain outside the club. His suit showed the stains of four sets of concert combat. Rising to wash his hands from the greasy chicken, he nearly toppled into the sink.

"Fantastic!" he was all smiles now. "What a gig! What a compassionate audience! You know, I'm always pleased when I'm not humiliated. They wanted me to do well."

He sat back down on the sofa and allowed himself a victory glass of wine. His work was done for this night but his mind was racing towards the future.

"I want to do a lot of work, really work for the next few months. I want to make songs that'll really stand for this moment. This time I'm in now, this age of 40, this season of winter."

He paused and looked at his hands.

"I think I'm getting old. My nails are crumbing under the assault of the guitar strings. My throat is going. How many years more do I have at this?"

No one in the room said a word.

"If one's health holds out, then doing this forever would be marvelous. To really bring the information of the older ages – you don't hear that on the concert stage. Maybe we'll be able to hear John Lennon in 40 years on his experience of maturity. That's what I'd like to hear and that's what I'd like to be. Every man should try to become an elder."

And with that closing remark, Field Commander Cohen stood up and looked in the mirror and fiddled with his collar and his suit until he passed inspection and then he strode out to the bar to greet the waiting troops.

Over the last 40 years since that night in New York, Leonard has become an elder. And I've been privileged to witness his journey both as an audience member and as a friend. There are so many wonderful memories. About a year after the Bottom Line shows I was travelling with Bob Dylan and his Rolling Thunder Revue (the entire experience documented in my book *On the Road with Bob Dylan*) and we were in Montreal to play a show. Dylan implored me to call Leonard and get him to come to the performance. Then he dispatched me and his wife Sara in a cab to pick up Leonard to make absolutely sure that he'd be in attendance and, just as important, that he'd sit in

and sing a couple of songs. My strategy was to get Leonard drunk and persuade him to sing but when we approached his modest house on St. Dominique, I could already hear the sound of music wafting out in the street. I walked up to the front door and it was slightly ajar and I walked into a cacophony of harmonicas, spoons, kazoos and spirited voices. Leonard was leading the orchestra, blowing on a harmonica and signaling the beat by stomping on a chair.

"How are you my friend?" Leonard said, without interrupting the music. "This is Hazel, Suzanne, Armand, and Mort. Pull up a chair."

But I was on a mission and I tried to corral the group towards the waiting cab.

"We have time for one more song," Leonard urged.

"But Sara's in the cab," I protested.

"Bring her in!" Leonard gestured expansively. And alcoholically. I spotted many empty wine bottles on the table. He had beaten me to the punch, so to speak. Leonard offered me some wine but I refused and pleaded for the group to leave.

"OK troops," Leonard barked. "Bring your instruments to the car." Leonard pulled a top-coat over his gray suit, the same suit that he wore to the Bottom Line gigs.

Suddenly the other four mutinied and they broke into a jig around the living room, whooping and hollering and waving their hands in the air. We finally corralled everyone and piled into the cab. On the way to the venue, they whipped out the spoons and sang some French folk songs.

We made our way backstage and Joni Mitchell rushed over and hugged Leonard.

"Joni, my little Joni," Leonard said affectionately.

"I'm glad you're here. I just came off though," she said.

"Well, we just heard the greatest music I've ever heard. The greatest music I've ever heard we just played on the way over here," Leonard said.

By now, Dylan had walked over. "Leonard, how are you doing?" Dylan greeted him warmly.

"Hey, Leonard, are you gonna sing?" I implored.

"Let it be known that I alone disdained the obvious support," Leonard said with mock solemnity. "I'm just going to sit out there and watch." And he did.

/

Another memory. Leonard and I are breaking bread in some restaurant in New York at the end of 1984. He has just come from a meeting with Walter Yetnikoff, the suit who ran Columbia Records at that time. Leonard had brought Yetnikoff the finished tape of his new album, *Various Positions*. Leonard described to me how he played the album from beginning to end in Yetnikoff's office. When it was over, he looked to the executive for a reaction.

"Look Leonard, we know you're great," Yetnikoff said. "But we just don't know if you're any good."

And then he told Leonard that Columbia wasn't going to release the album in the U.S.

I was furious. I considered *Various Positions* to be one of Leonard's finest works. And I was convinced that Yetnikoff was a Philistine for refusing to release it in the U.S. but eager to take in the

profits from the substantial sale of the record in Canada and Europe where Leonard had a much greater audience.

From that time on, whenever I bumped into Yetnikoff at various Columbia Records functions, I would confront him like an avenging angel.

"How dare you not release *Various Positions?*" I'd say. "Shame on you!"

/

Other random memories: sitting in Leonard's L.A. kitchen, eating TV dinners watching *The Jerry Springer Show* with delight. Having coffee with Leonard at the Café Borgia in SoHo as he described how he sat on the floor of his hotel room in Manhattan, in his underwear, agonizing as he wrote verse after verse after verse of "Hallelujah." Telling me that he practiced Zen meditation so ardently that he wore out the cartilage in his knees from sitting cross-legged for so long. Discussing metaphysics for hours and hours, from the Kabbalah to The Sermon on the Mount, in his view the greatest challenge ever made to mankind. "There is no afterlife. This is it," Leonard once told me. "And the world is a butcher shop."

But on the positive side, Leonard also told me that as we age the brain cells associated with anxiety begin to die, so, no matter our actual physical deterioration, it won't feel that bad.

/

That there even was a tour for Sharon Robinson to document is a miracle of sorts. Leonard was never really big on touring. In 1985 he played 77 concerts all over the world but not of his own volition. "This is the first time in my life that I have to work to support my kids," he told me. "It's nice meeting people. Other than that, it's bleak, it's bleak." In 1993 he played 37 concerts in the U.S. and Canada and, so he thought, hung up his touring fedora for good. But in 2004, five years after he came back down from Mt. Baldy after being ordained as a Zen monk, he learned, to his dismay, that his longtime trusted manager had embezzled almost $9 million from his retirement accounts and trust funds. He was left with about $150,000.

But he still didn't want to tour. He was unsure whether anyone still cared about his musical enterprise. But necessity being the mother of invention, Leonard's musical director, Roscoe Beck, came to L.A. in 2007 and began assembling the wonderful cast of musicians for the tour. Of course, Sharon Robinson, who in the intervening years between tours had become a close collaborator with Leonard on some of his most beautiful recent songs, was slotted to sing back-up along with the lovely Webb sisters, Charley and Hattie, who Sharon had brought in after they had collaborated on some songs for the sisters' album.

The ensuing concerts were breathtaking. Leonard's voice was more magisterial than ever, the arrangements were sublime, and he treated each and every audience to a show that lasted well over three hours. And, when others his age could barely make it to their early-bird dinners, he ended each show by skipping off the stage! I saw two of the New York shows, one at the newly renovated

Beacon Theater and one at Radio City Music Hall and the joy and excitement in seeing our elder Leonard bringing us the "information of the older ages" was palpable from the first song. And, thankfully, for those who couldn't get to any of these shows, we have two records, *Live in London* (out on DVD too) and *Songs from the Road*, that document those wonderful musical gatherings.

And now we have Sharon's book of photos as a visual record of all those years on the road. Thank the Lord for her iPhone and her eye. Like a fly on the wall of every venue, every hotel room, every tour bus, every chartered plane, she gives us a visual record of Leonard's triumphant return. What the pictures clearly show is a musical army in great harmony traversing the globe. There are beautiful landscapes and cityscapes shot from airplane or hotel room windows. A photo of a microphone in front of an empty arena, offering silent testimony to the heavenly music to come. Fans lining up at stage doors are juxtaposed with long solitary marches through graffiti filled tunnels on the way to the stage. Nothing escapes Sharon's roving eye, including a dressing room wall that Sinatra signed back in 1986. And then there are the photos of Leonard.

Only Sharon could have disarmed Leonard to the point where he actually looks comfortable before her lens. There's Leonard on his knees singing to an empty audience at sound check. Leonard with a guitar strapped to his back holding onto the rail on an airport tram. Leonard drinking coffee, Leonard sightseeing, Leonard chomping on a hot dog from a street vendor. Leonard happy. Leonard pensive. Leonard eschewing his usual fedora for a tweed newsboy cap.

And the piece de resistance—Leonard doing his laundry at a public Laundromat, wearing a topcoat and his fedora. That alone is worth the price of the volume.

/

There is one photograph that Sharon did not take, though. That's because she was onstage at the time as Leonard closed his 2009 tour with an emotional concert on September 24 at the Ramat-Gan stadium, near Tel Aviv in Israel. It was three days after his 75th birthday. He lined up his musical troupe at the front of the stage and addressed the crowd as Sharon hummed angelically in the background. Leonard made a plea for Israeli-Palestinian reconciliation and lauded a peacemaking group who strived for that end for their "victory of the heart over its own inclinations for despair, revenge, and hatred." Then Cohen raised his hands and gave the Priestly Benediction that he, as an elder, but more importantly as a Kohain, was authorized to give.

May the LORD bless you and guard you
May the LORD make His face shed light upon you and be gracious unto you
May the LORD lift up His face unto you and give you peace

And I say, "Right back at you, Old Leonard, right back at you."

Sincerely,
L. Sloman

INTRODUCTION

by
Sharon Robinson

One afternoon in March of 2008 the phone rang. Leonard Cohen and Roscoe Beck were on the other end of the line. They had been trying to put the final touches on the casting of the band and asked me to come in and sing for a possible spot on the tour. At the time, I had a bad case of laryngitis and could hardly speak, much less sing. They said, "But we know you *can* sing, right?" I croaked, "Right!"

At that time, I had been working on some arrangements with Leonard for what would eventually become his album, *Old Ideas*. He came over one day and described the latest in the now well-known financial disaster that he was in the midst of. "Darling, I think I'm going to have to go on tour!" No one knew at the time, including Leonard, how wildly successful, long running, and deeply satisfying that tour would be.

I have worked with Leonard Cohen for many years in different capacities, and as co-writer, singer, and producer over the last 35 years I have had the good fortune of always having an excuse to hang out with the man. He's an artist's artist, a loyal friend, and for me, the headmaster of the school of life. To know LC and work with him closely has often caused me to reflect on how lucky I am.

So when that call came in March of 2008, a call I was not expecting at all, I couldn't wait to get over to SIR rehearsal studios and....sing? Well, my voice did eventually clear up, and by mid-May, band and crew were headed to Northeast Canada to start the Leonard Cohen Unified Heart World Tour.

Not knowing if he still had an audience, Leonard started small, but it wasn't long before it became clear that there was not only an enduring interest in his music, but an enthusiastic embrace awaiting us from fans already steeped in LC's body of work and anxious to see what he was up to now, and also a remarkable number of new fans discovering his work for the first time.

/

Life on the road is a strange reality. Traveling with a group of 50 professionals from city to city, sometimes having to check the itinerary to see where you are, the next concert almost always in the back of your mind, dictating every choice leading up to it. It's an exercise in adaptation to changes in weather, environment, concert halls, food, language, latitude. Inside the bubble, we were anchored by our welcome rituals: the anointment with essential oils from LC himself, the round sung in Latin every night on the way to the stage, the hour-long sound check before every show—led by Leonard and conducted with discipline and professionalism by all, the friends and family, the before-the-show bonding in the green room, the passes, the protein drinks, the personal immersion in the music. There was a strong sense of family as a result of the music, the time spent together, and the singularity of purpose. There was the sheer majestic beauty of so many of the places we went, and the heartfelt words from fans after the show, evidence that we had all made contact with something greater than ourselves.

The concerts were transcendent. For many, it was a profound and spiritual experience.

This was not surprising, given that it was a detailed snapshot of Leonard Cohen's life's work. Being part of something so meticulously put together, and delivered with such heart and commitment, was a privilege not lost on any of us. There was a Zen-like focus that had to be maintained, that for us made the concerts both challenging and enchanting. Over the years, even though we played the same songs many times, the layers of meaning in Leonard's words still revealing themselves, and the varied and virtuosic way the musicians approached their performances made each concert a unique experience. In the off hours, we were surrounded by beauty, discipline, art, changing faces and cultures and aesthetic sensibilities. There was energy and excitement, movement and music, all cloaked in a certain dignity and serenity imparted by Leonard. There were flowers, gifts, friendships, marriages, babies. It was a world unto itself, and one I was compelled to capture.

The photograph that inspired me to keep shooting was one I took in New York City and used as the final image of this book. I had just had a brief encounter with Leonard on the street, and when we went our separate ways, we happened to be going in the same direction. Bundled against the cold, he was on a mission and walked briskly ahead. I found myself following behind him as he approached the large red letters of the Robert Indiana "Love" sculpture on Sixth Avenue. I had to take the picture. When I looked at it later, I was startled by the image. It seemed to have a life of it's own, and to contain something essential about LC. The stranger. The seeker. The one who speaks from the heart and whose work seeks to untangle the mystery of love, while embodying love itself.

/

Embedded with Field Commander Cohen, I kept my iPhone in my pocket so I could capture a moment in a second. I hope the spontaneous nature of this collection helps to convey how deeply emotional and extremely rewarding this journey was. Five years of touring spanning six years. Numerous cities and countries. Over 400 concerts, many of which were nearly four hours long. Everyone at the top of his or her game. Sometimes feeling like a family, sometimes feeling alone. Sometimes energized and excited to explore a new place, sometimes running on empty, homesick, and exhausted. But always thankful for the opportunity to be challenged to do our best work, playing exquisite music in a finely tuned band, with an exceptional crew, alongside Leonard Cohen, for enthusiastic audiences around the world.

Sharon Robinson

In memory of

My mother, Mildred Robinson *(1922-2013)*
My inspiration.

and

Our comrade, Steve Arch *(1952-2014)*
Funny and kind.
A good soul.

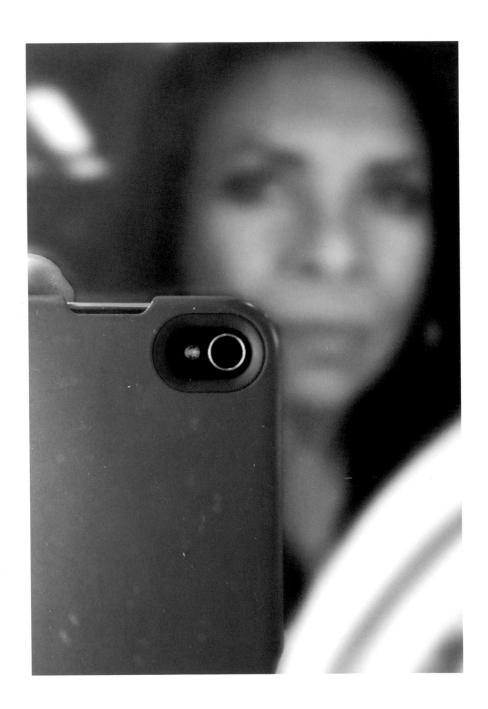

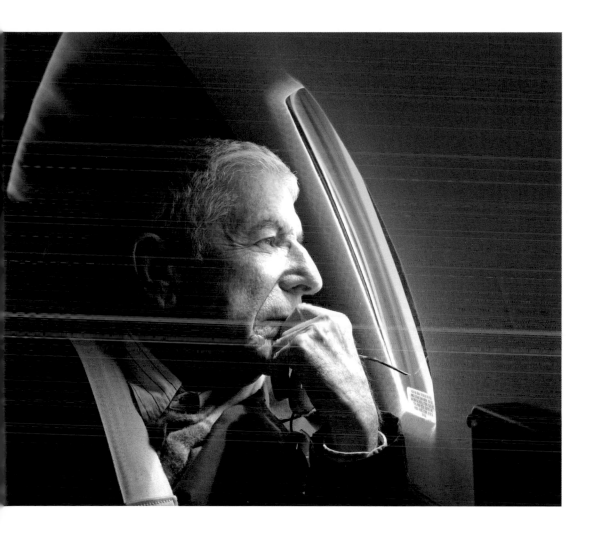

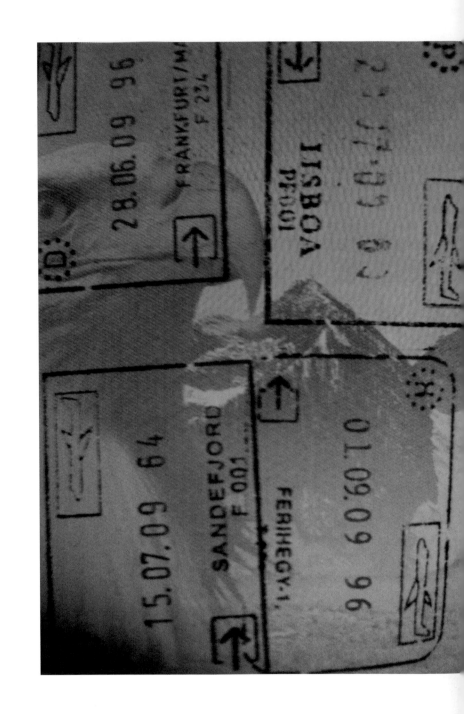

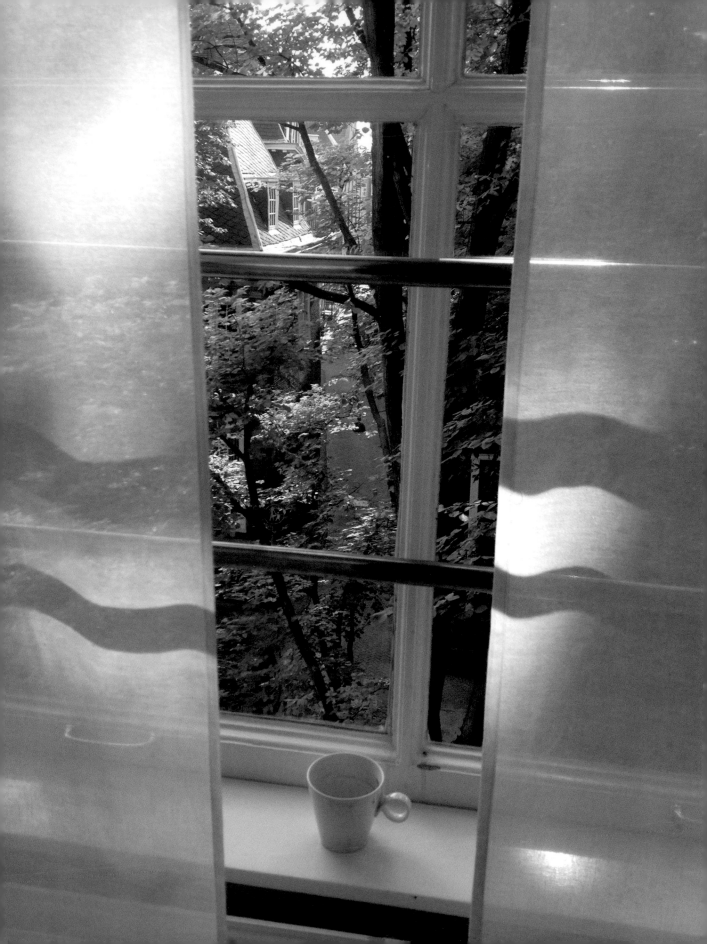

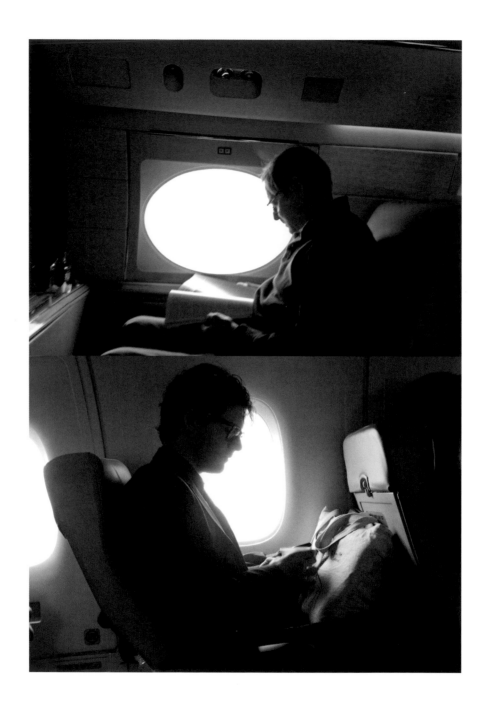

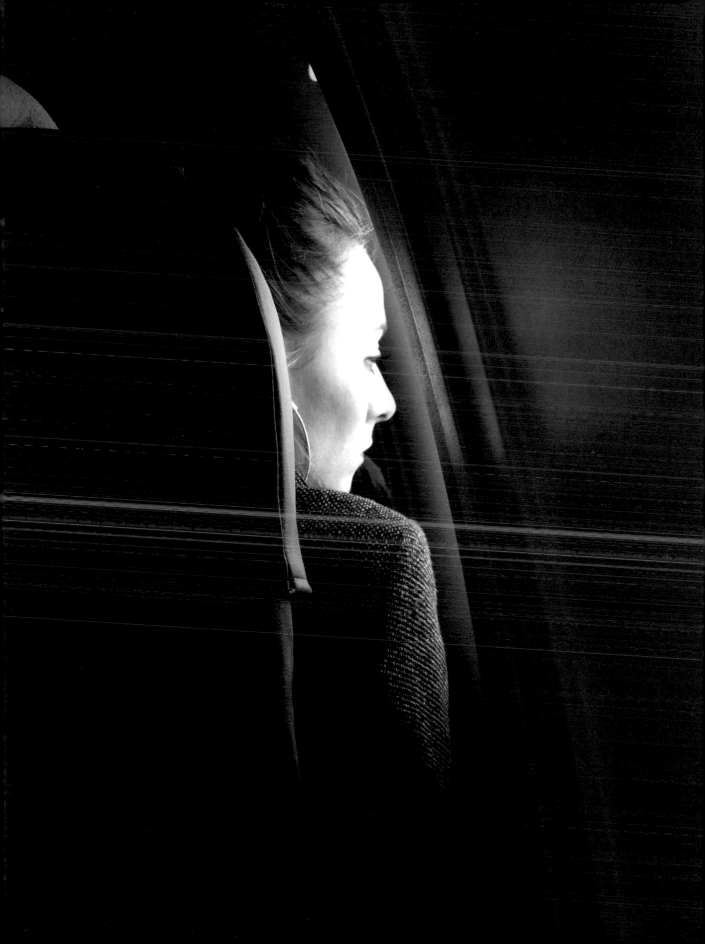

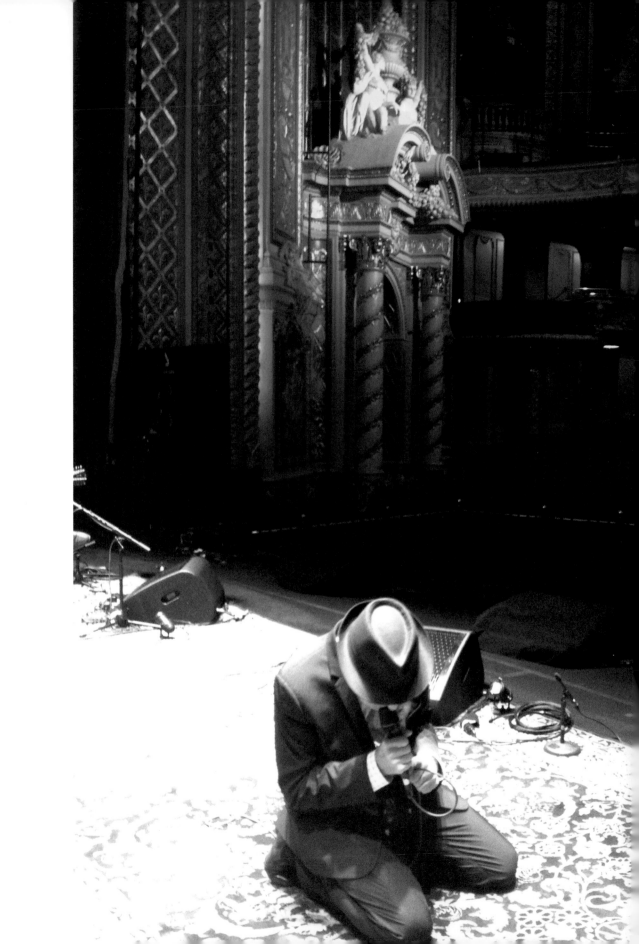

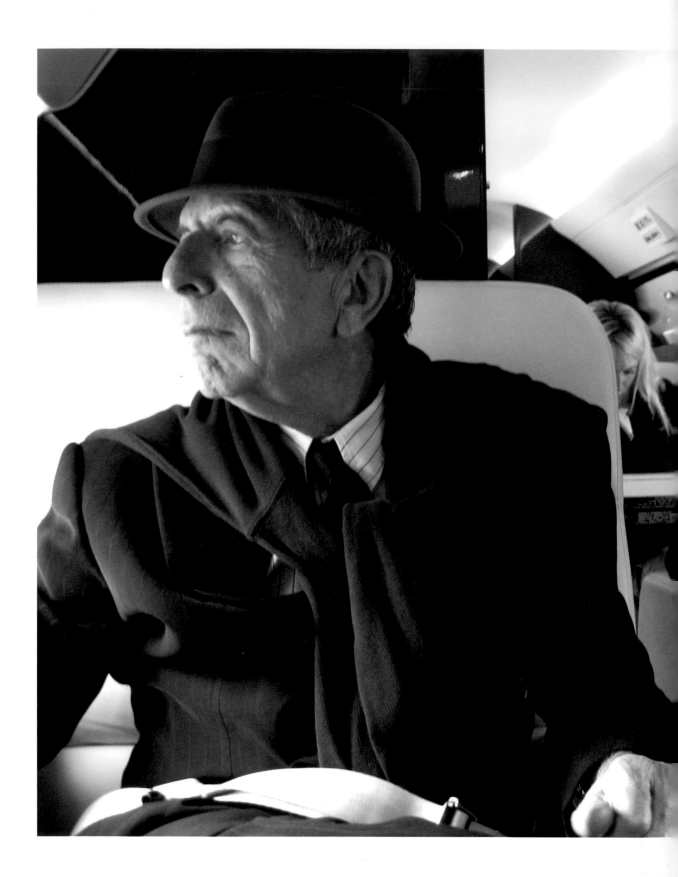

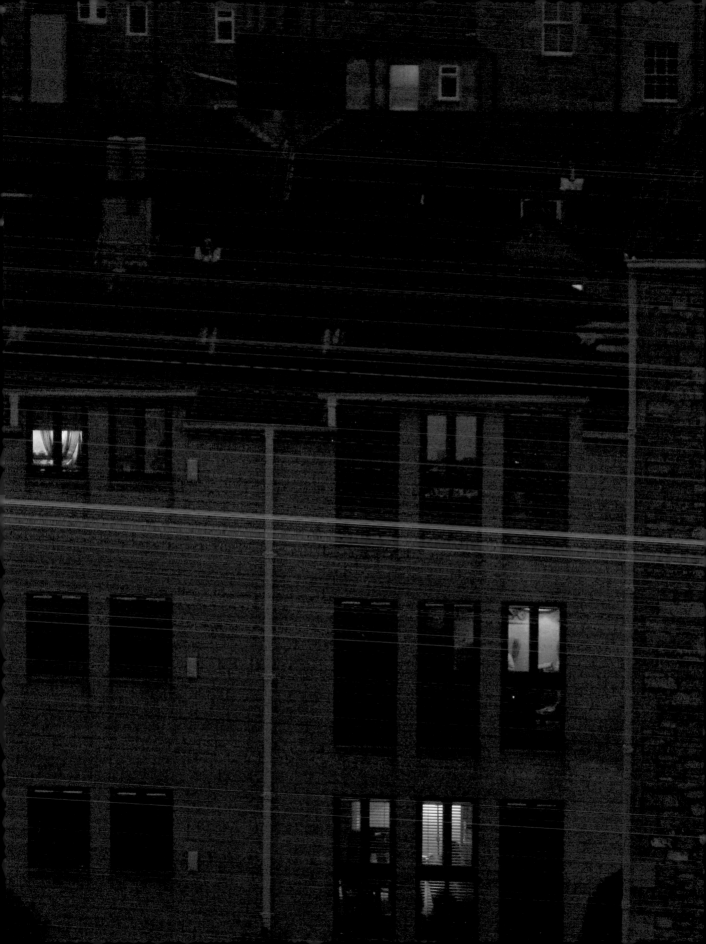

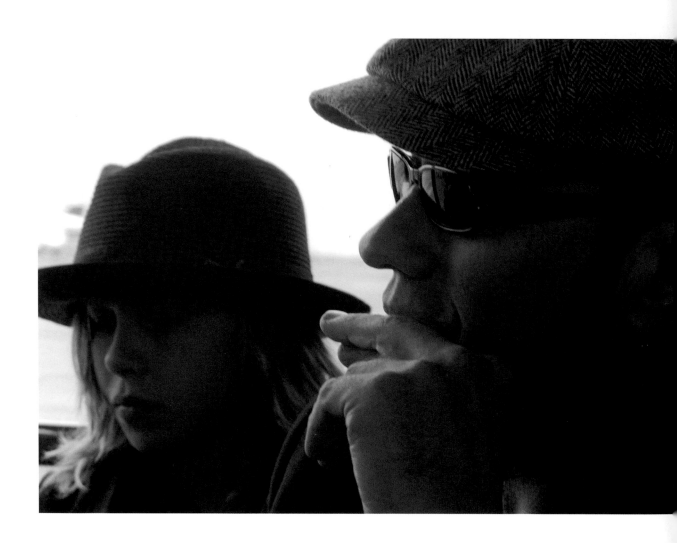

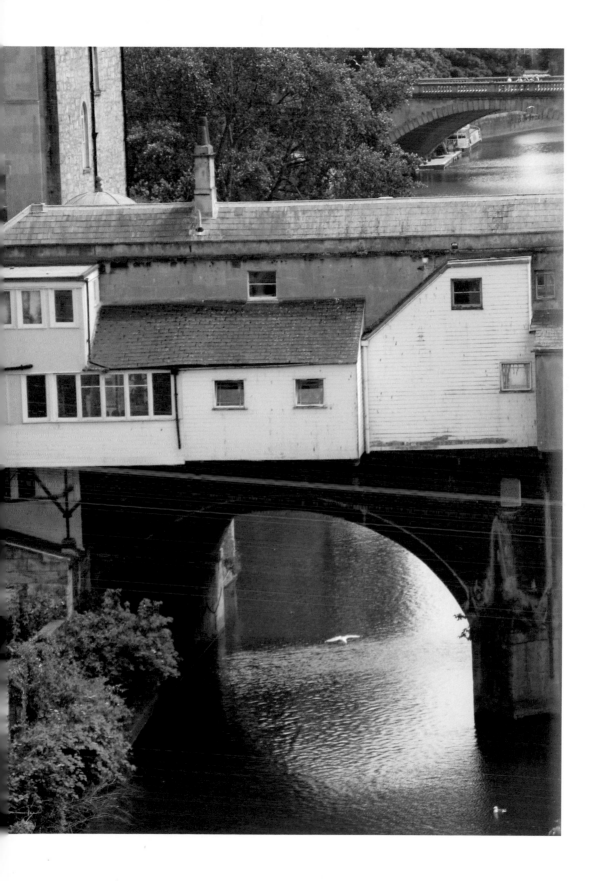

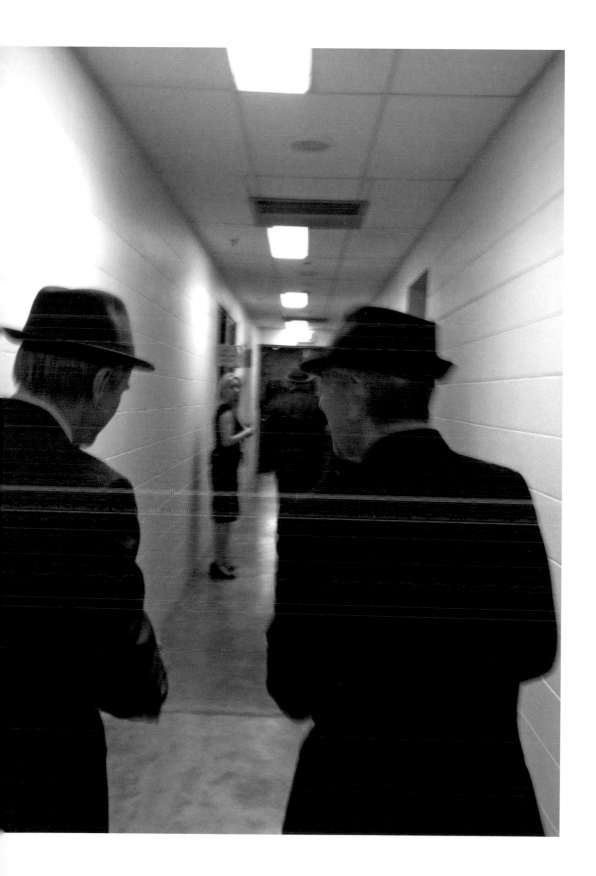

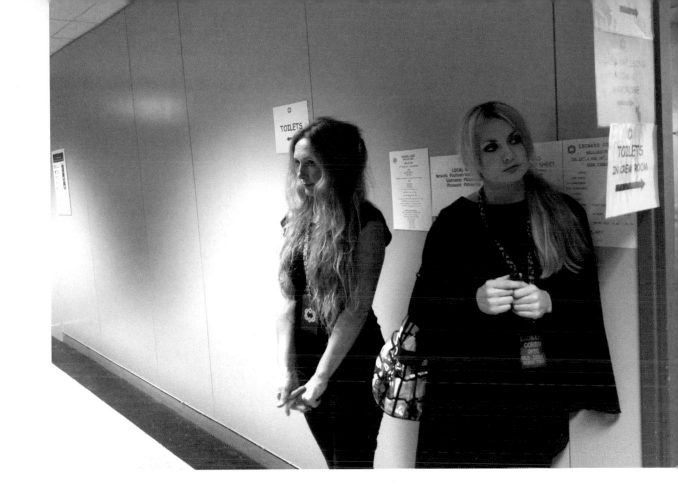

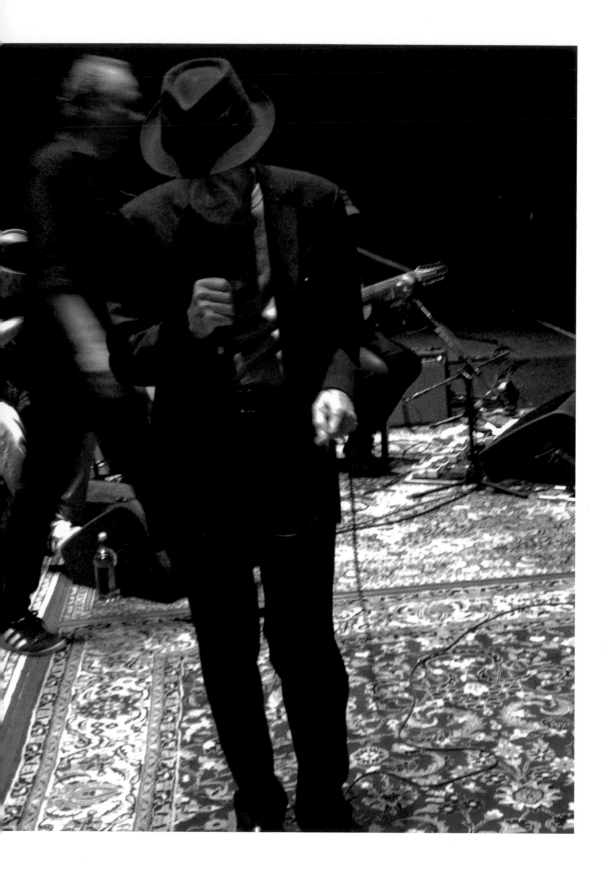

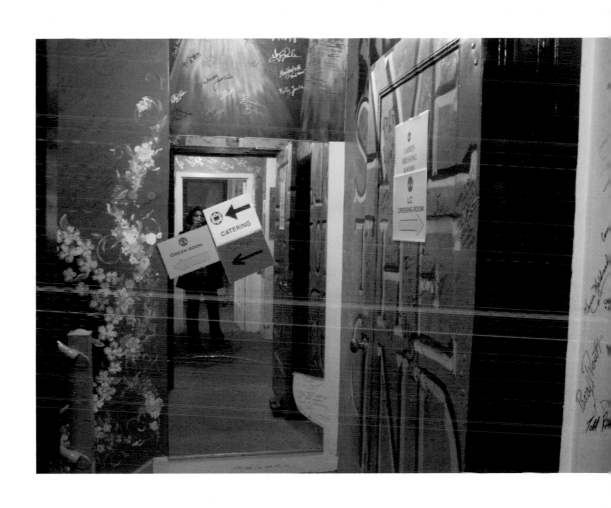

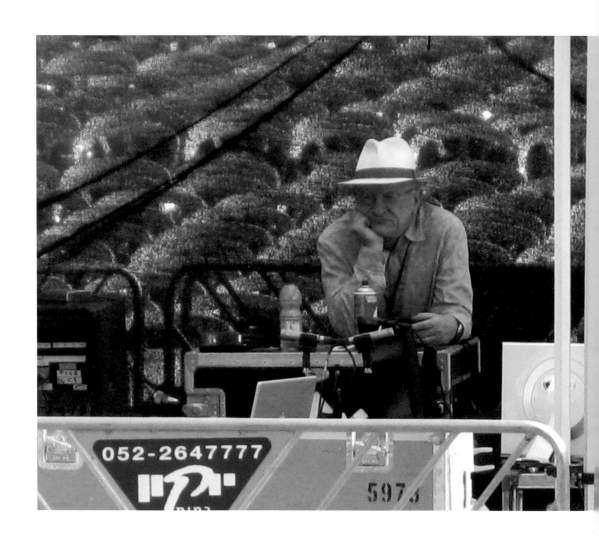

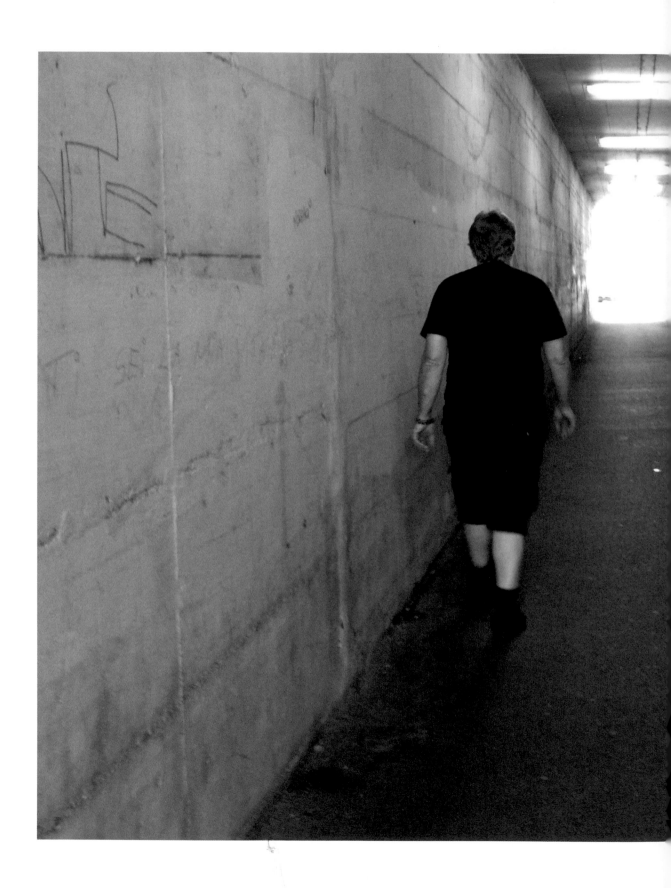

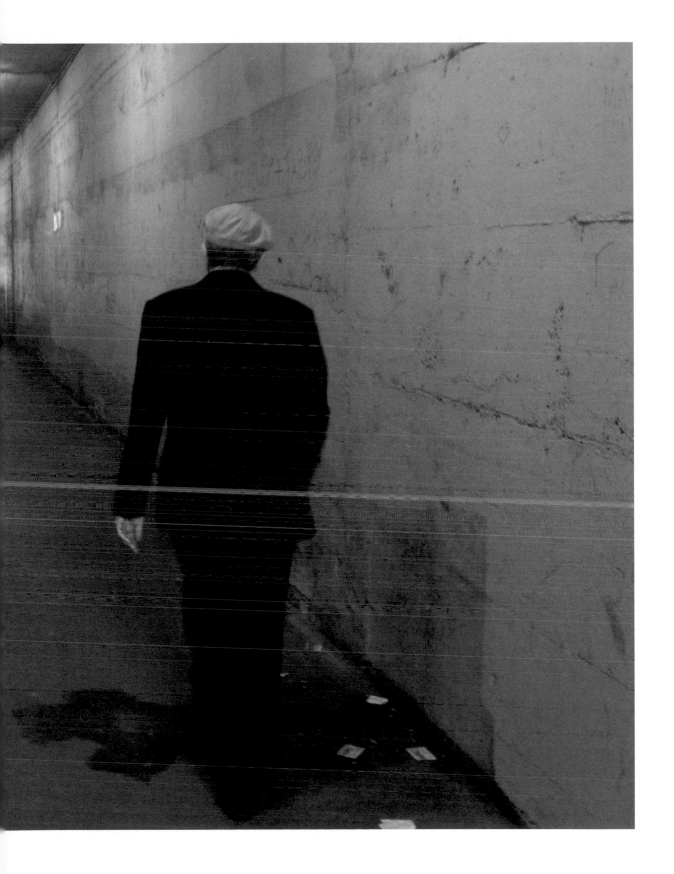

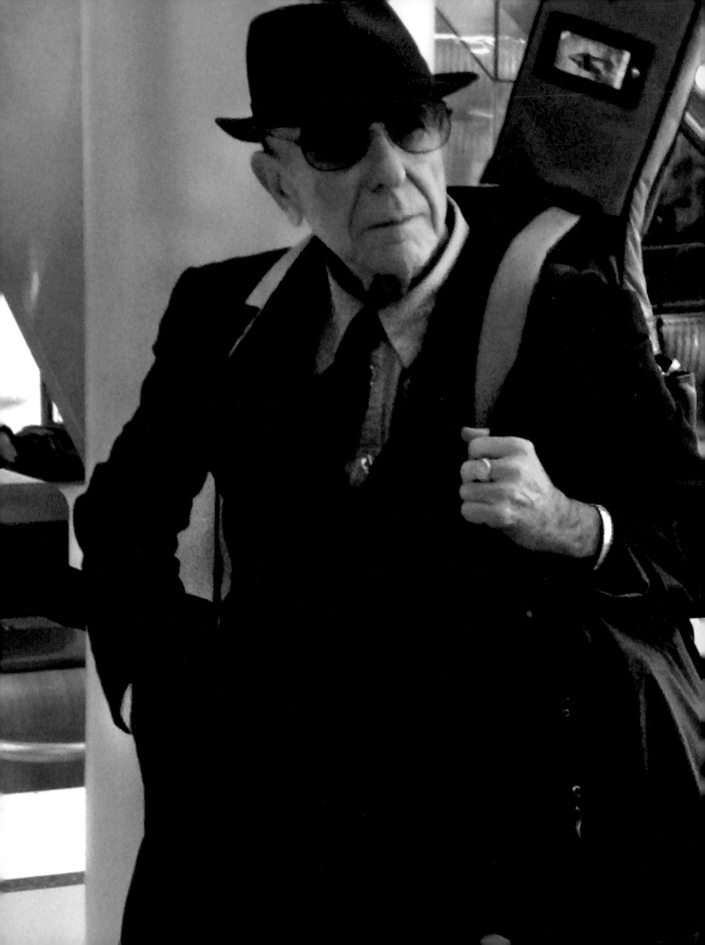

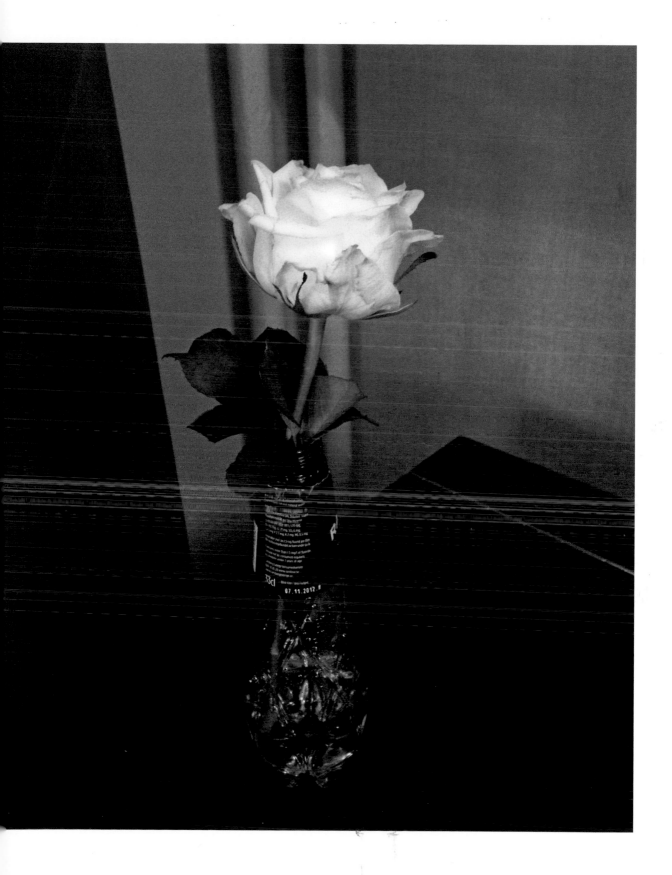

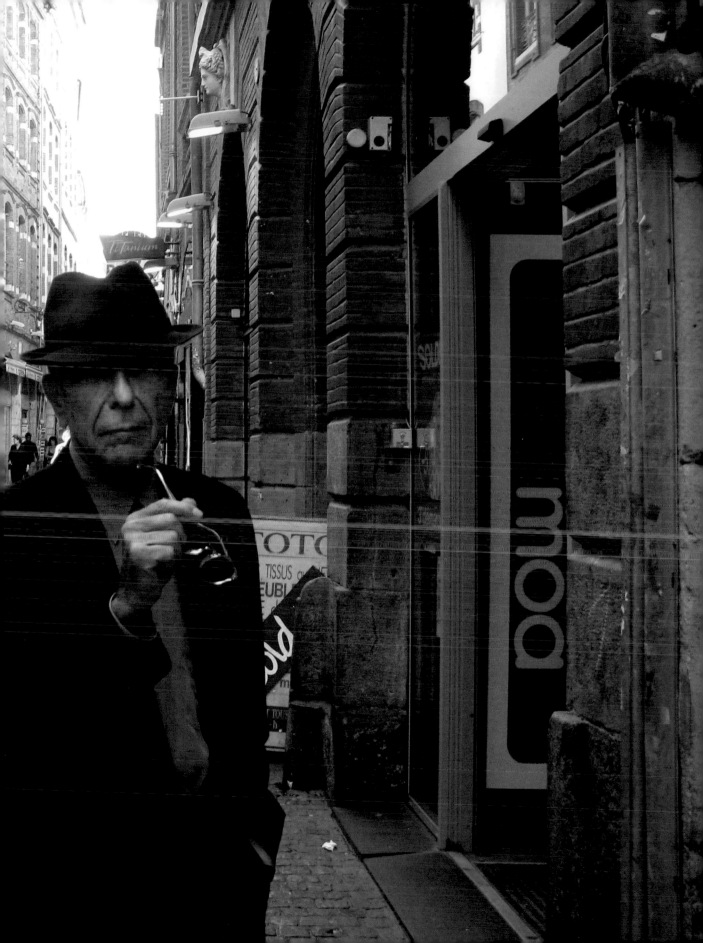

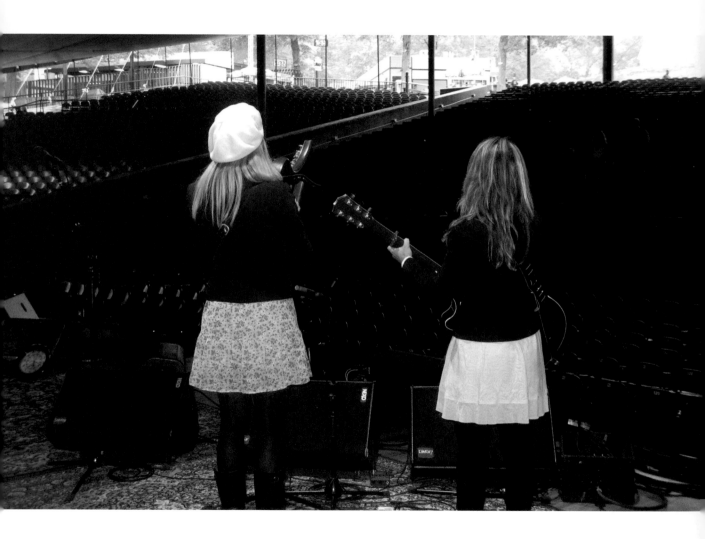

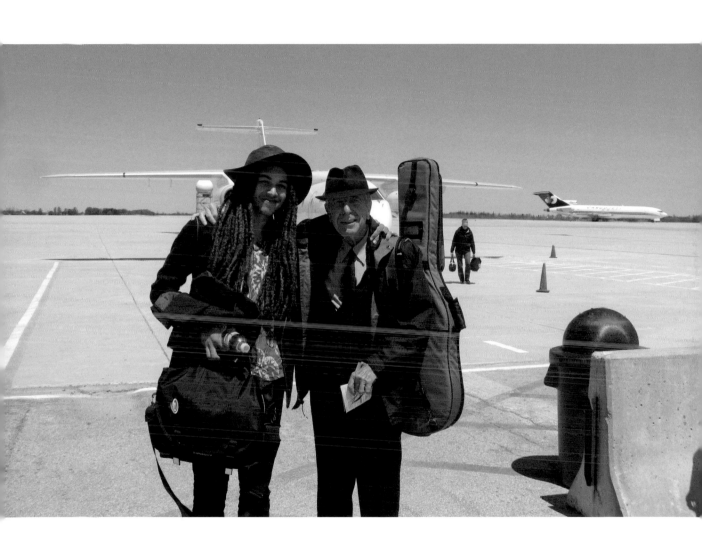

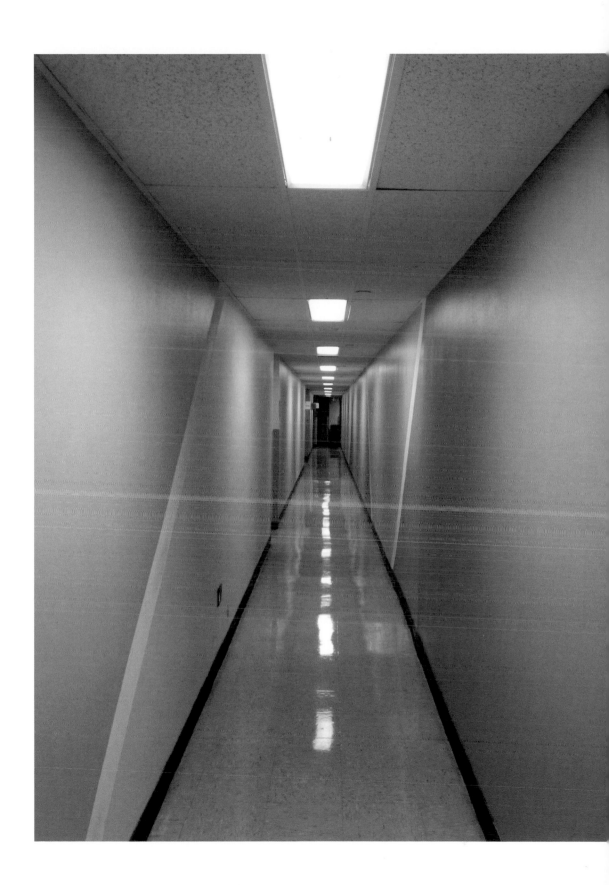

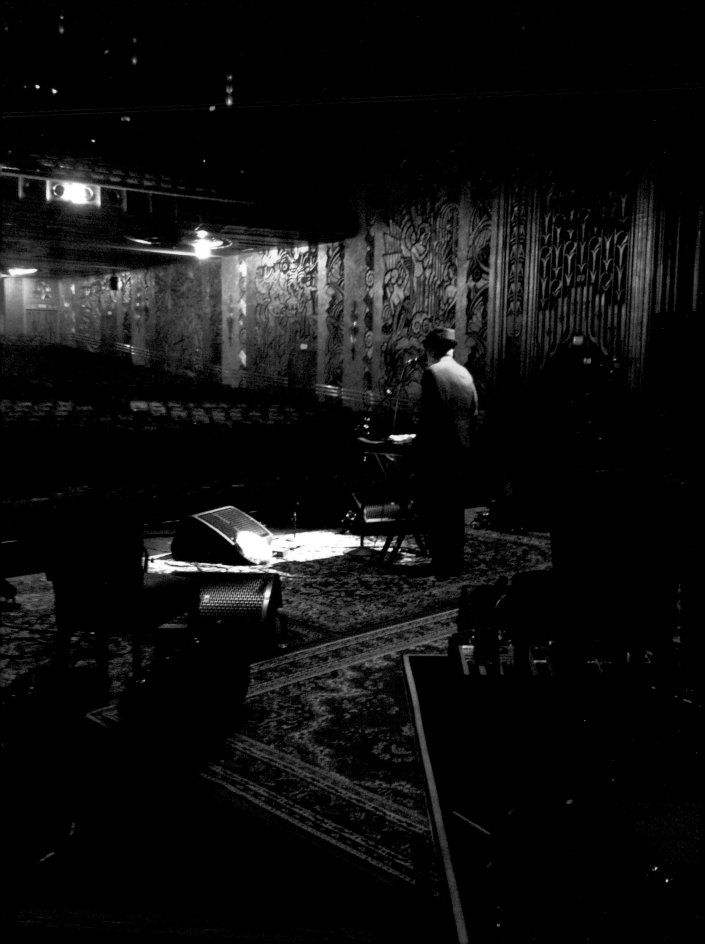

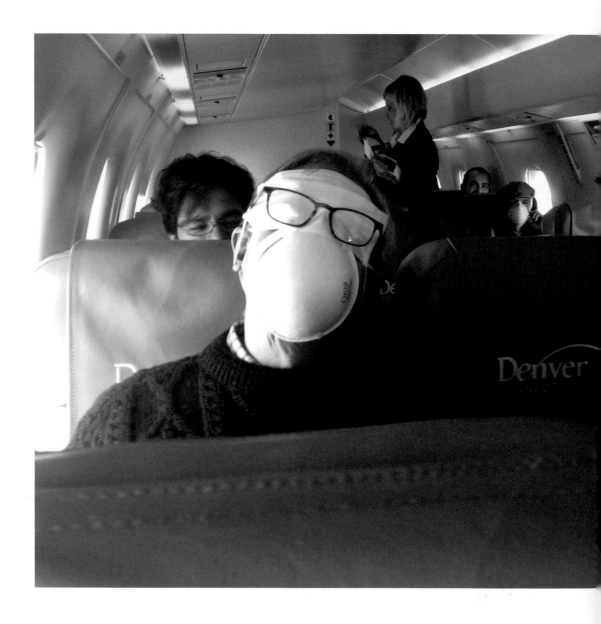

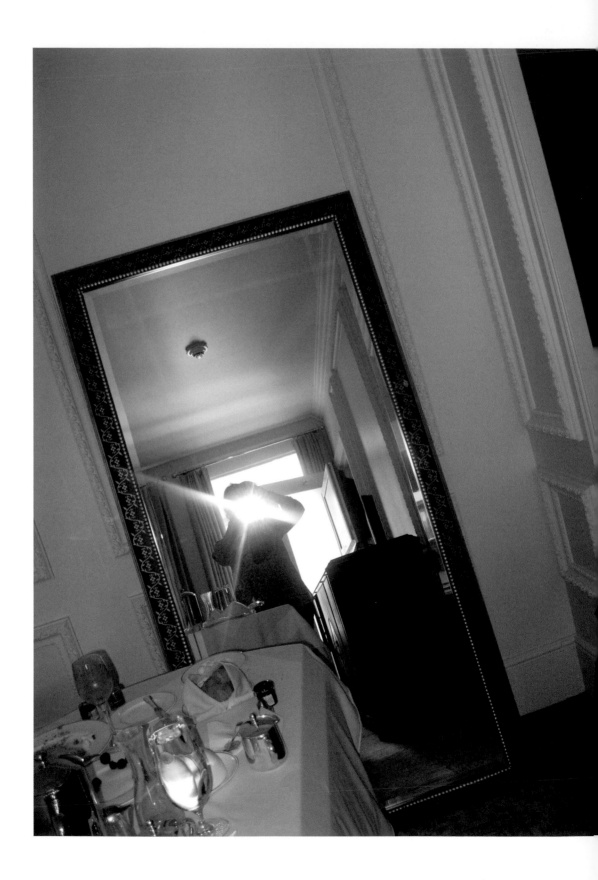

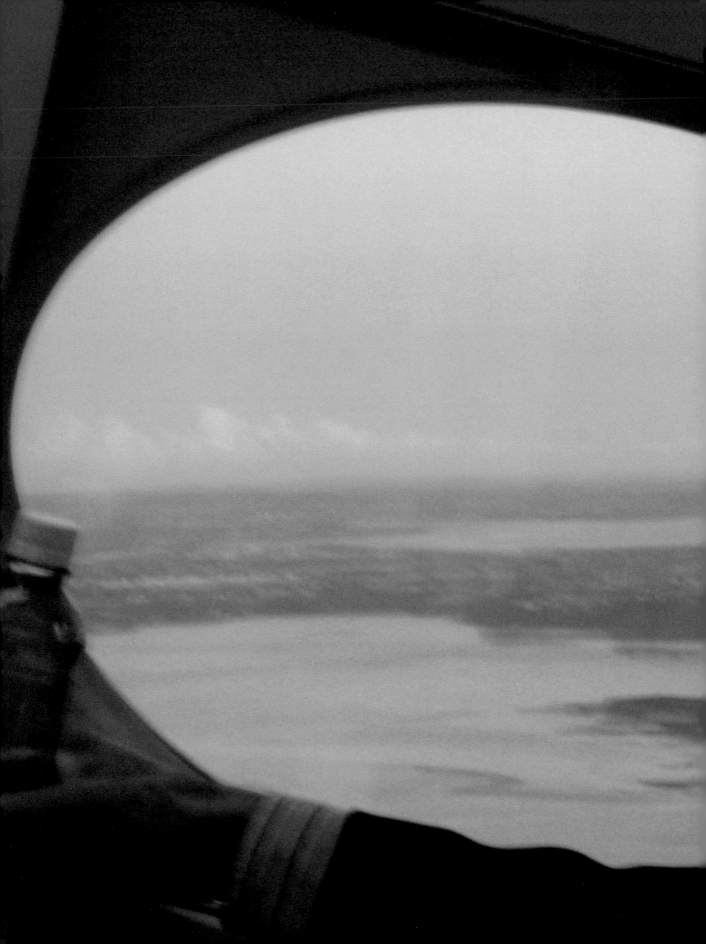

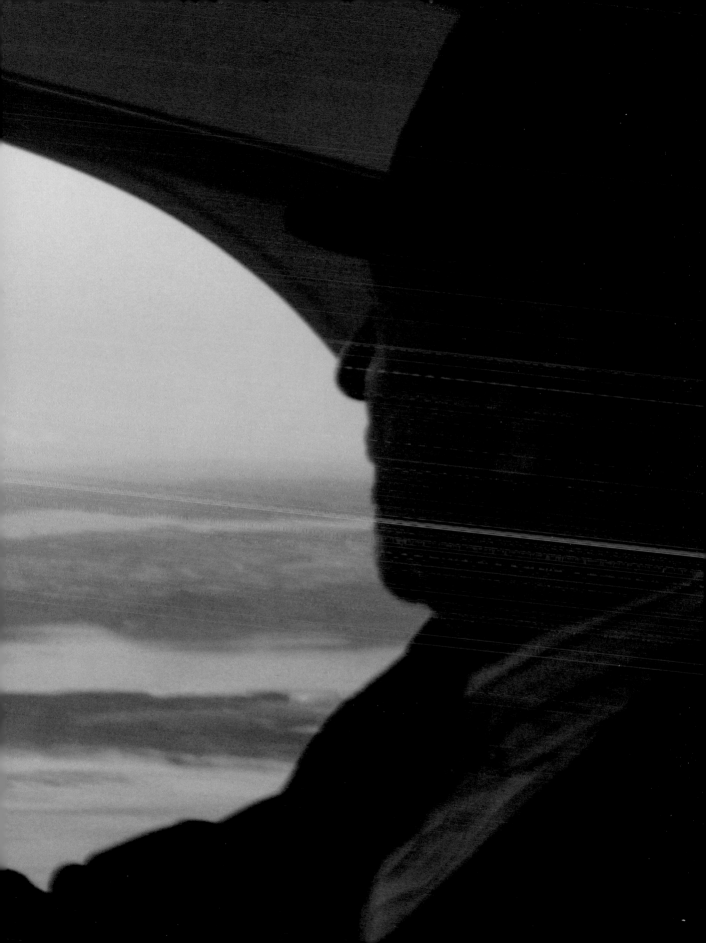

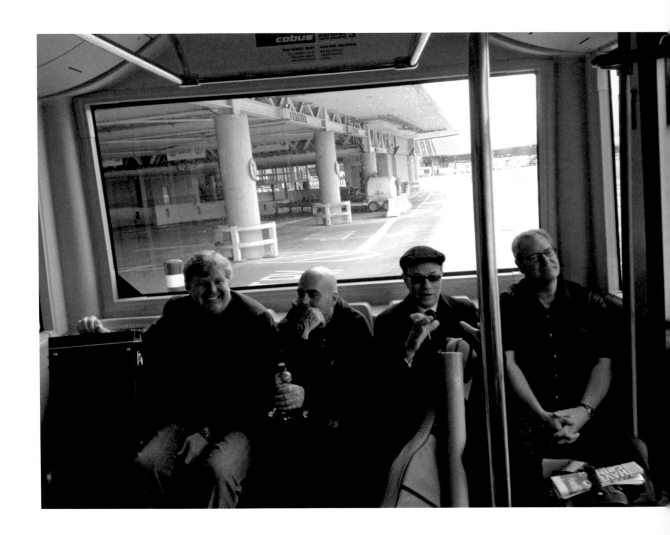

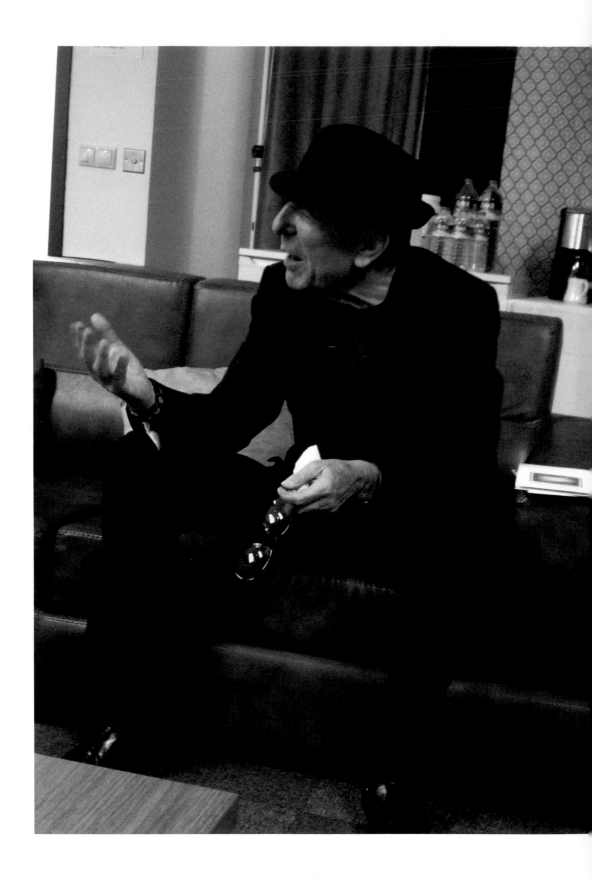

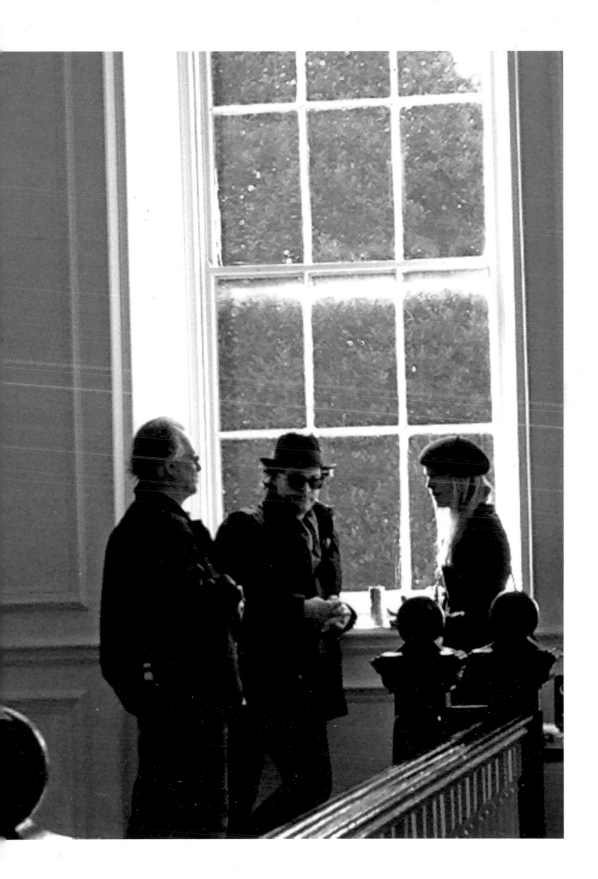

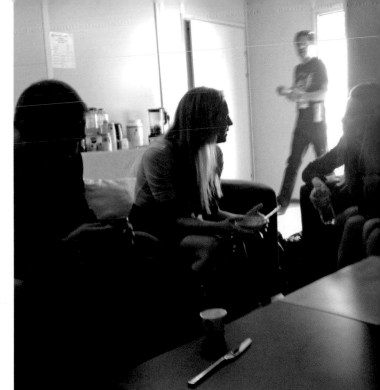

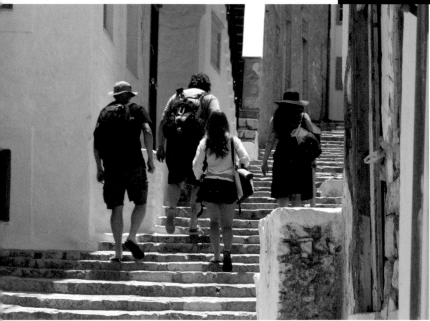

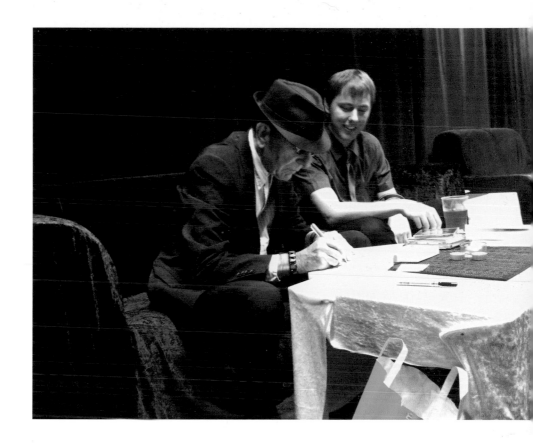

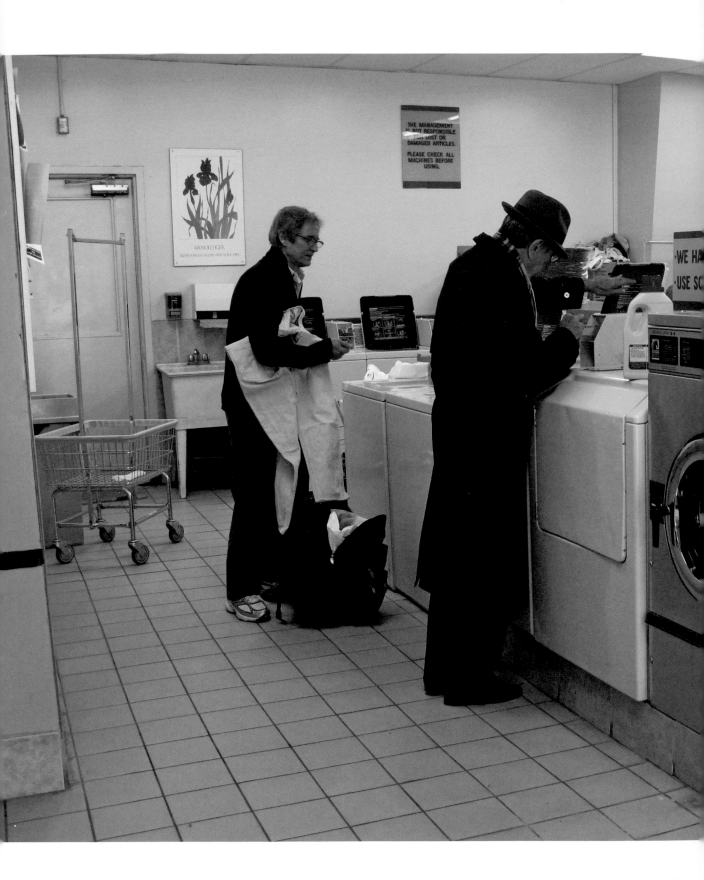

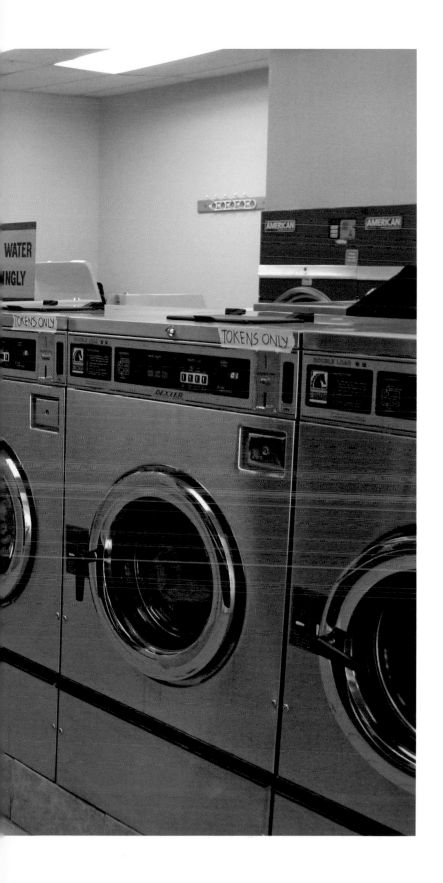

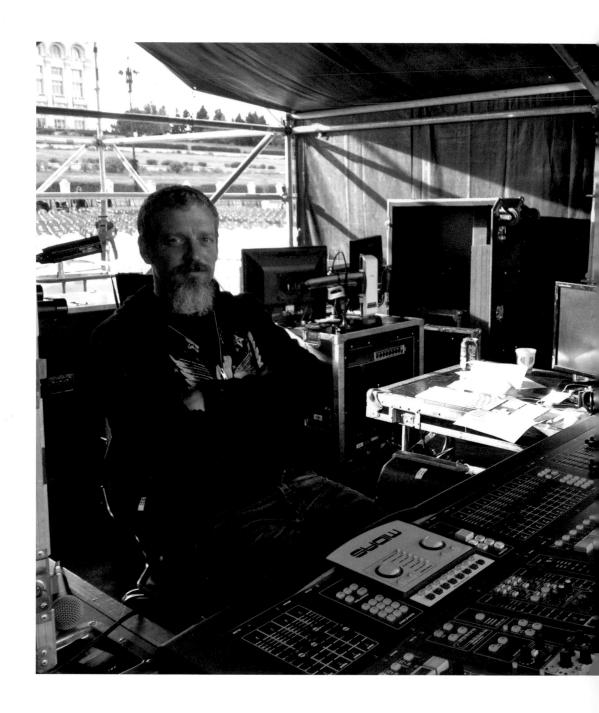

THE MANAGEMENT AND STAFF OF THE
BRISBANE ENTERTAINMENT CENTRE
WELCOME YOU.

BRISBANE
TIME

TOKYO
- 1 hr.

NEW YORK
- 15 hrs.

LOS ANGELES
- 18 hrs.

STAGE

TOUR MGMT &
PRODUCTION
OFFICE

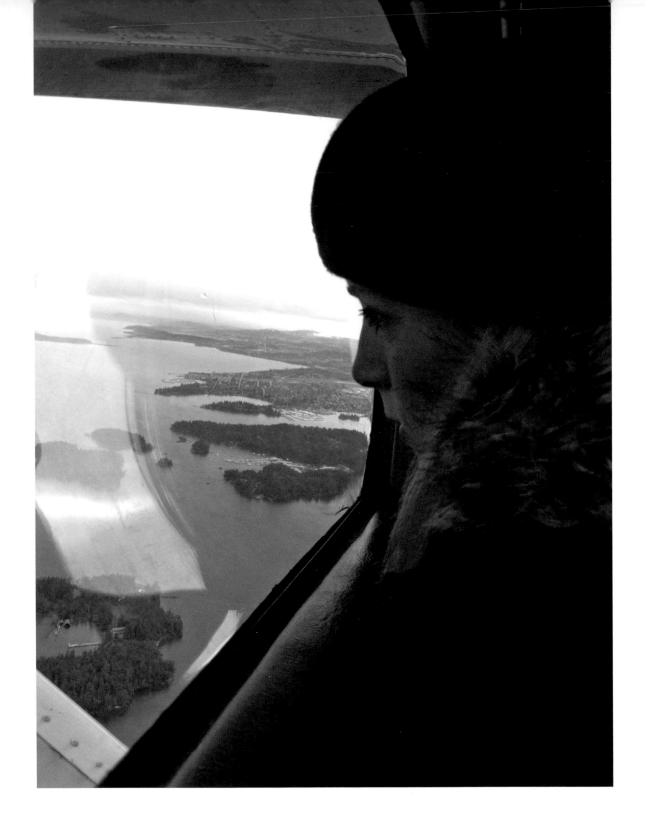

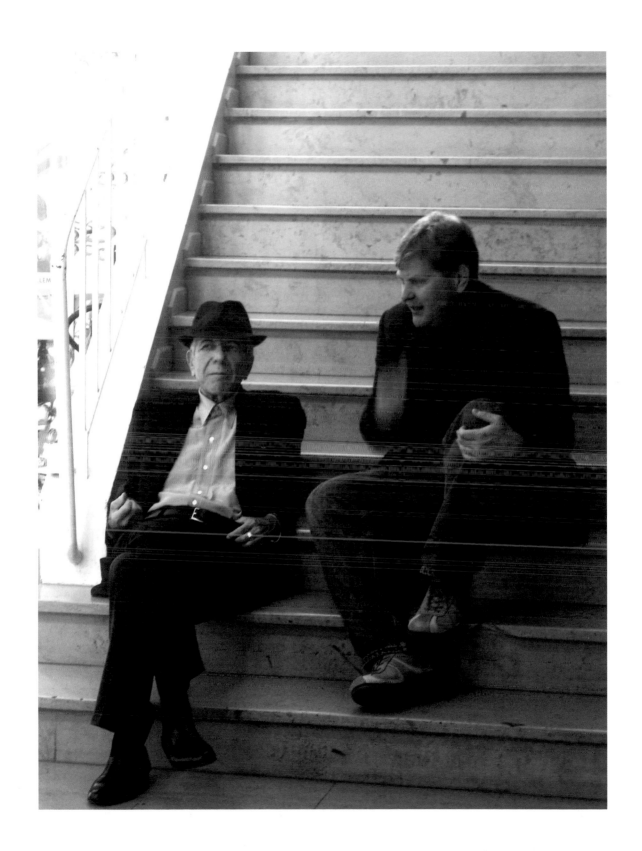

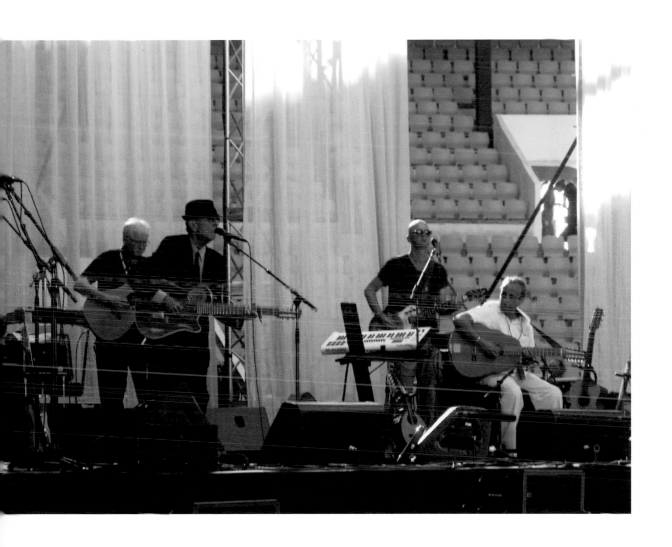

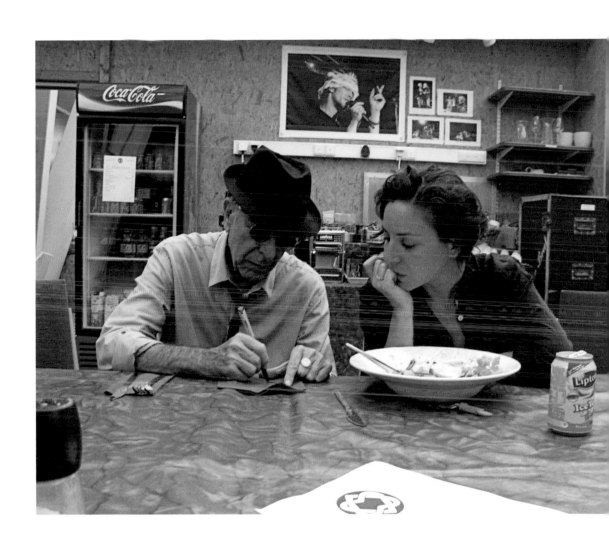

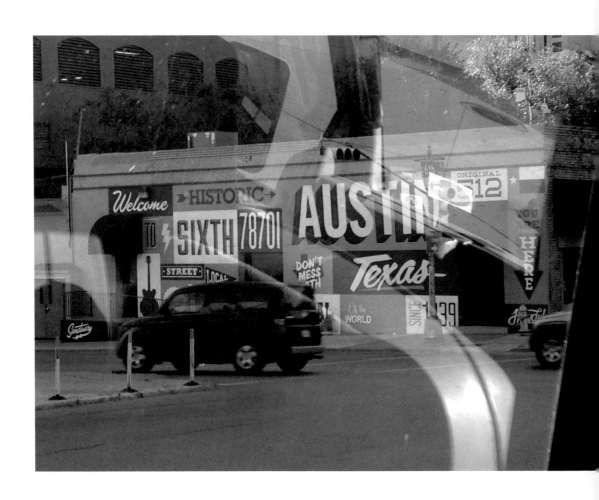

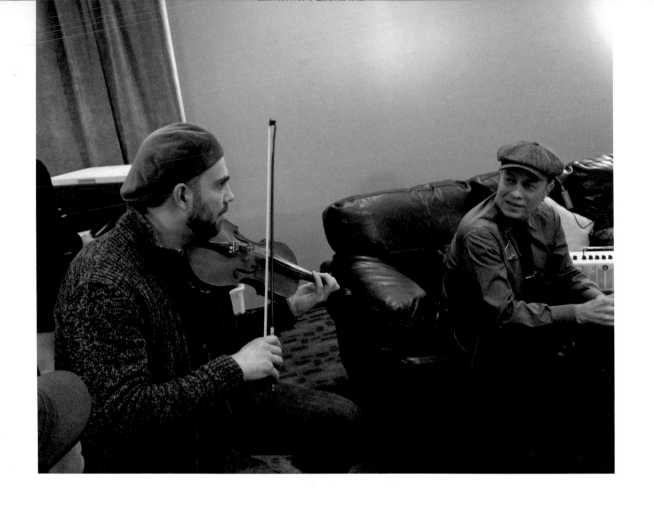

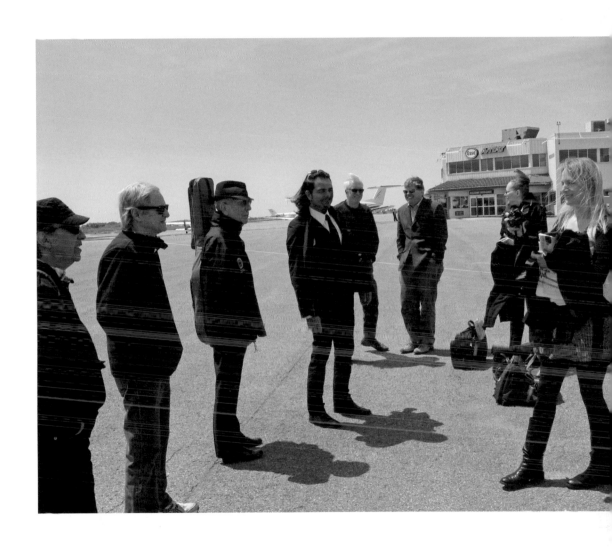

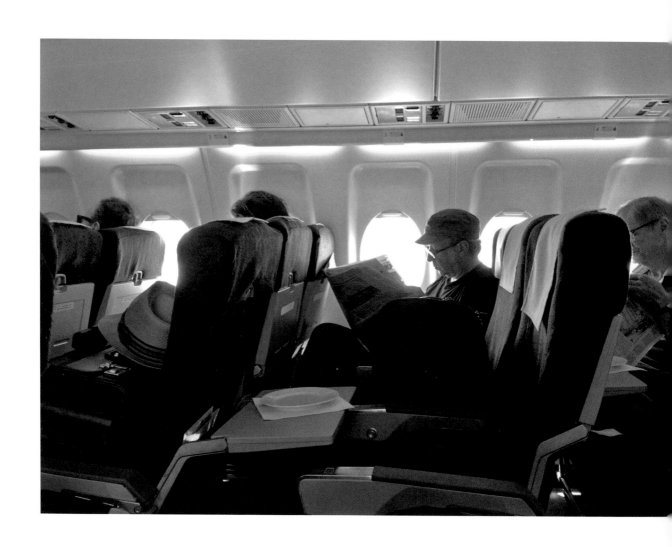

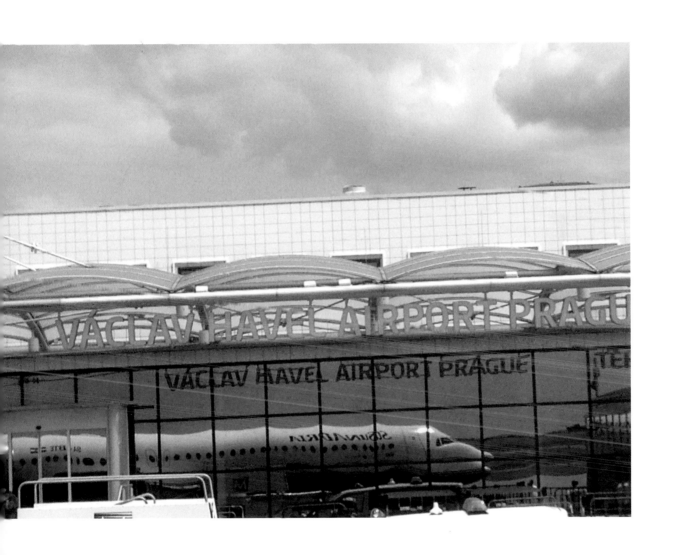

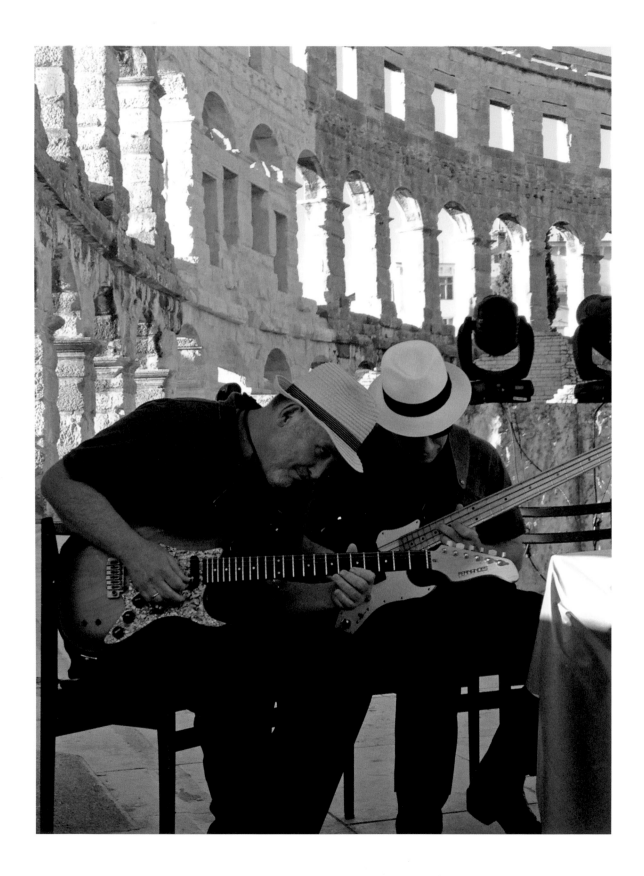

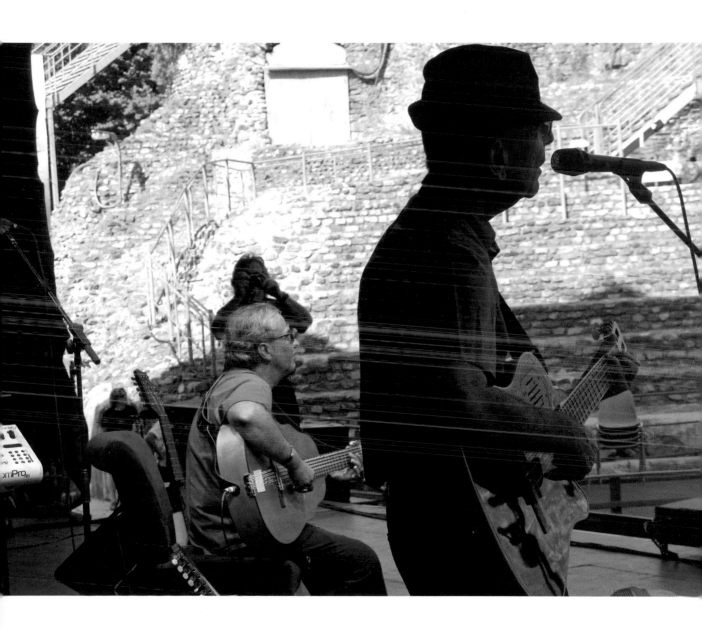

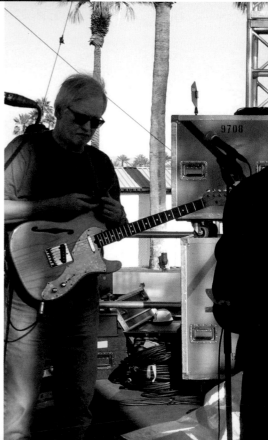

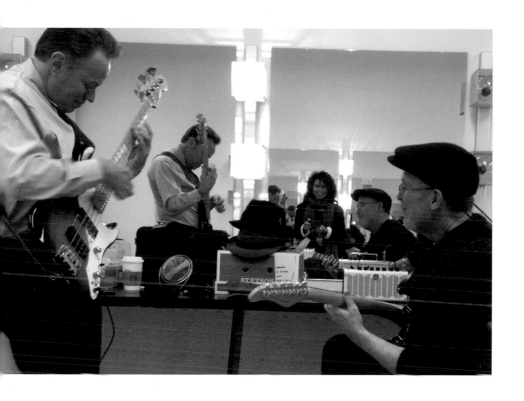

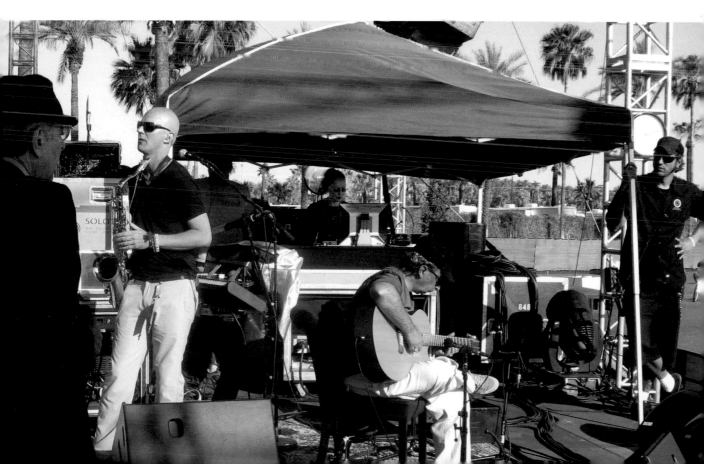

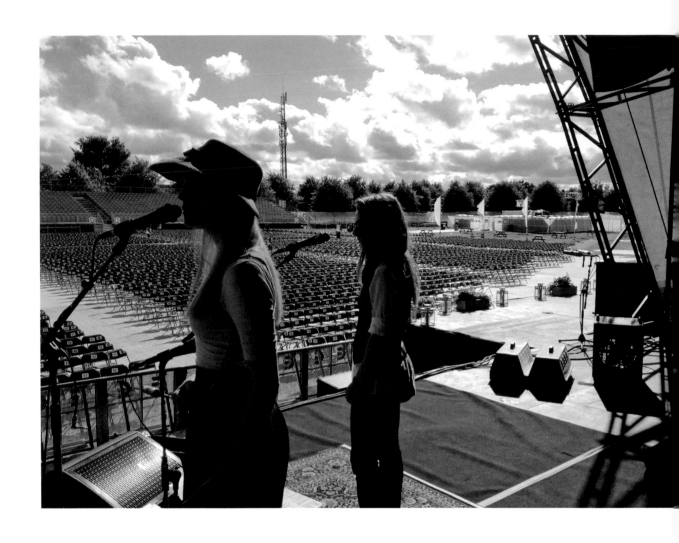

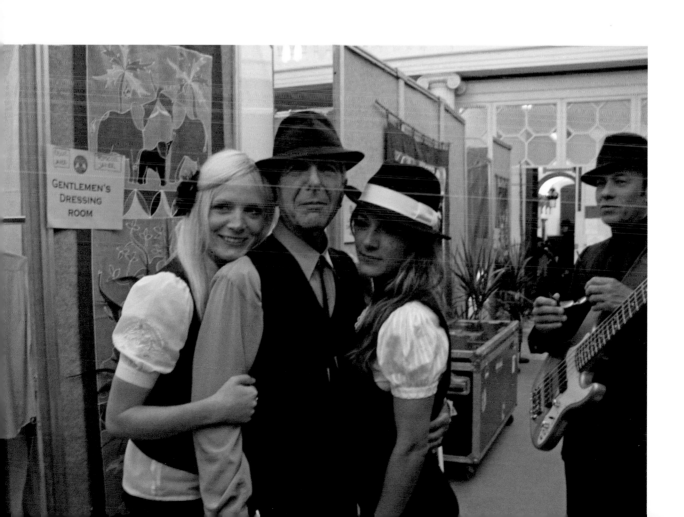

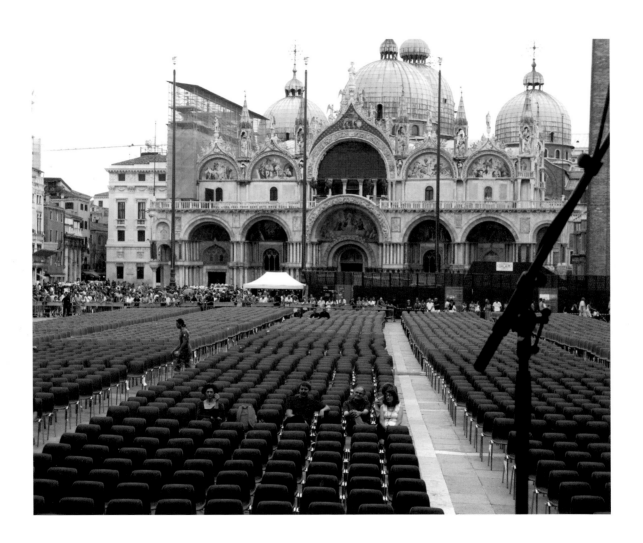

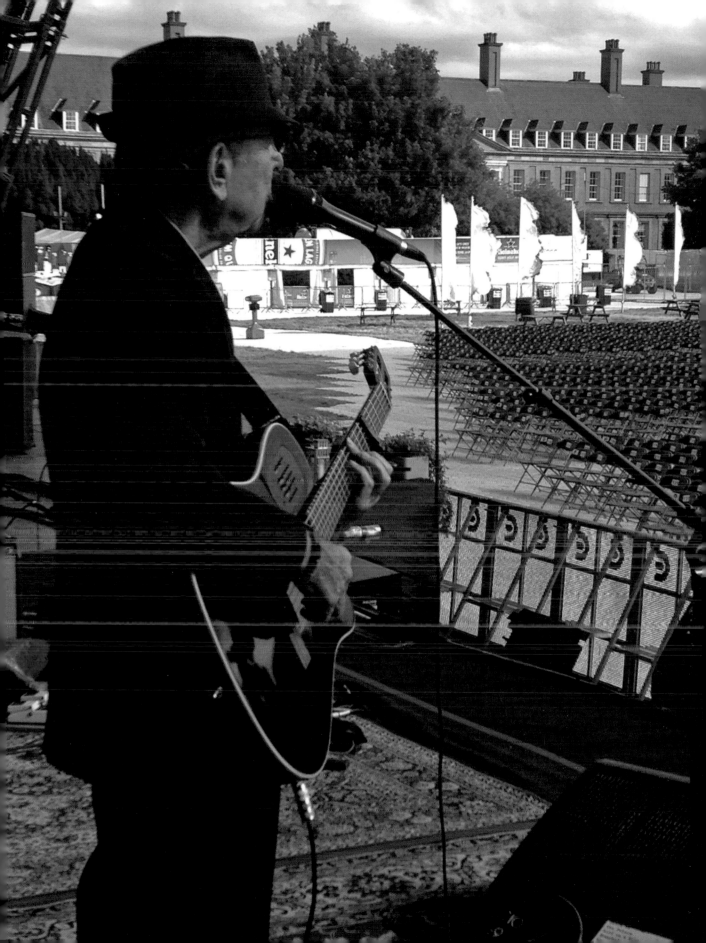

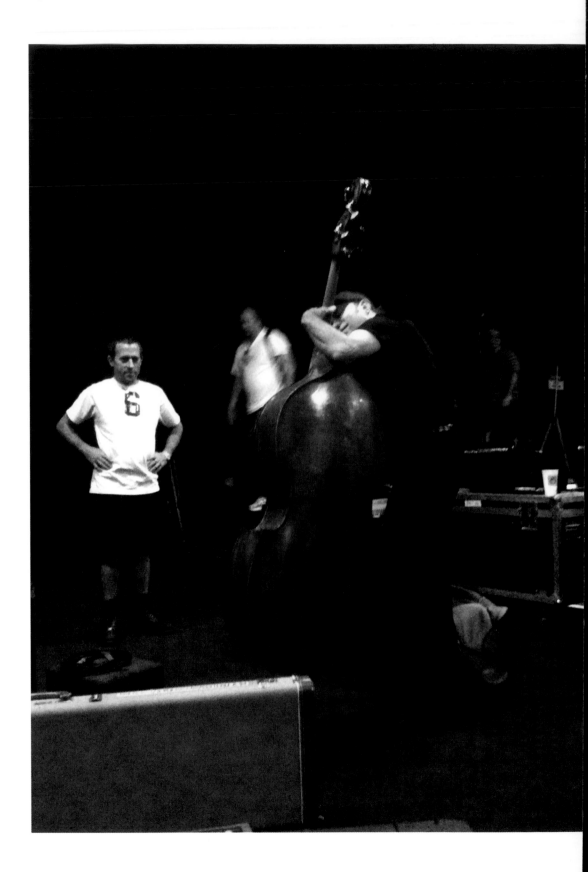

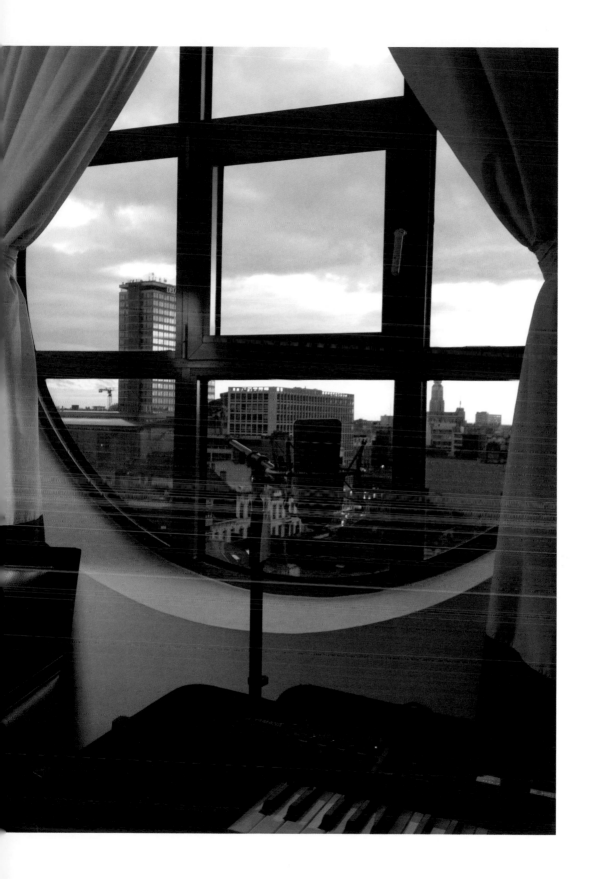

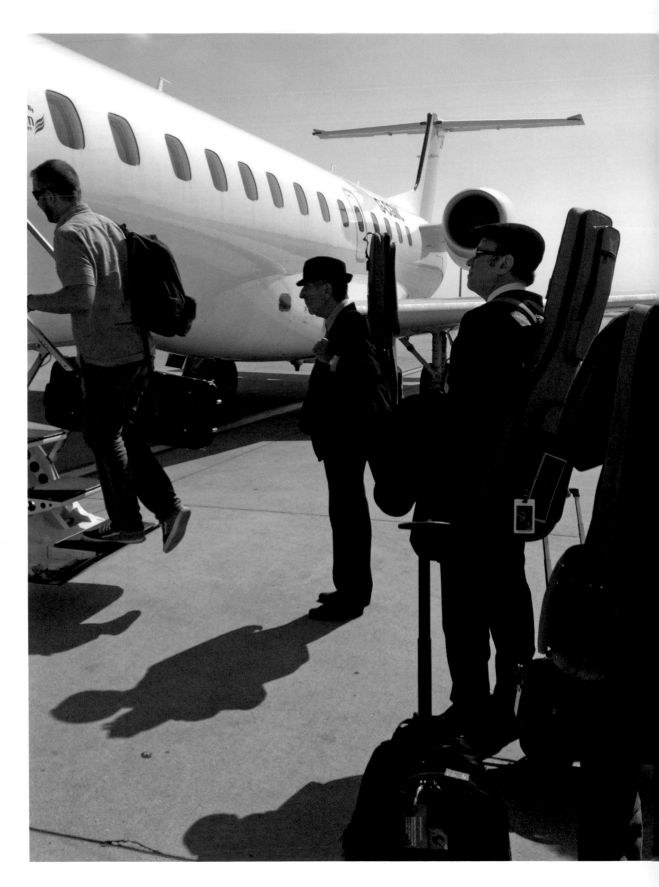

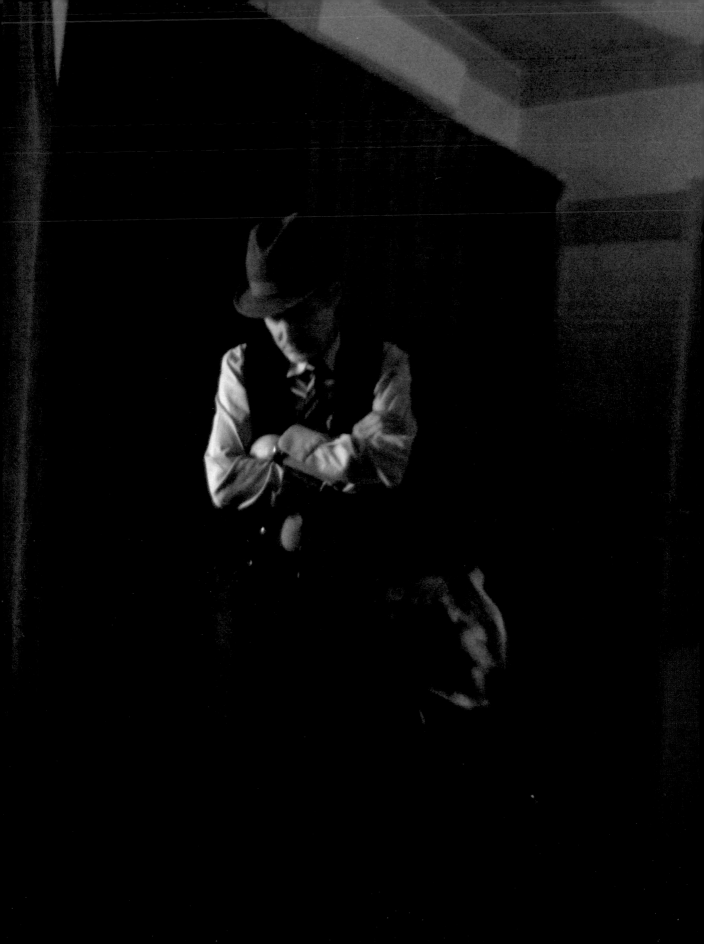

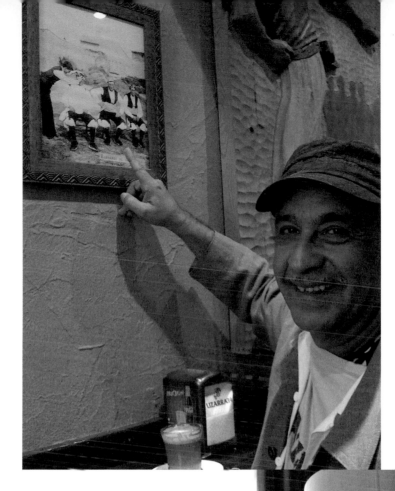

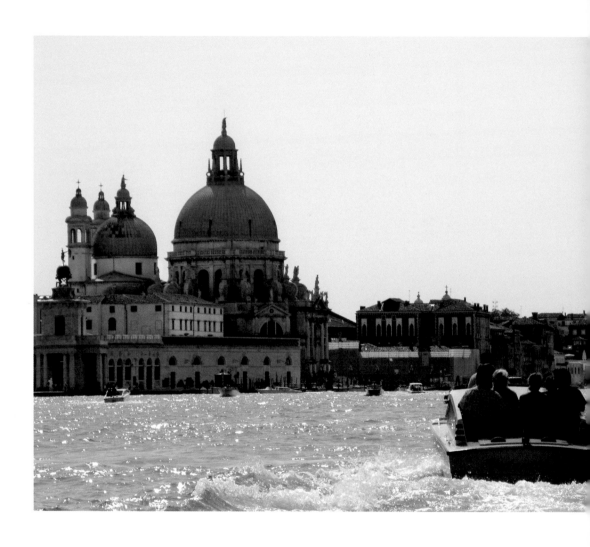

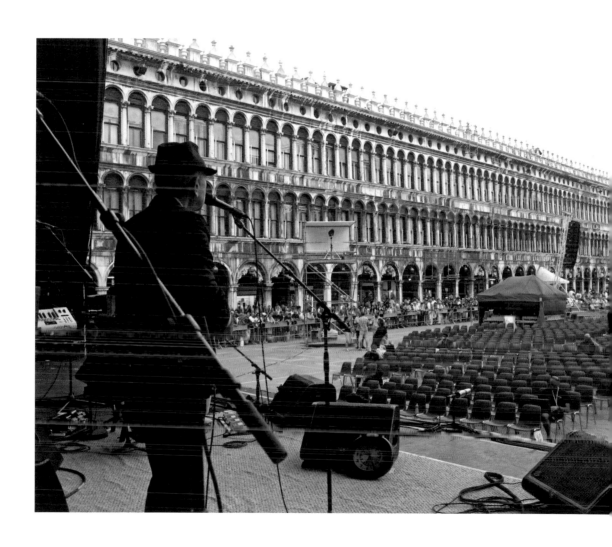

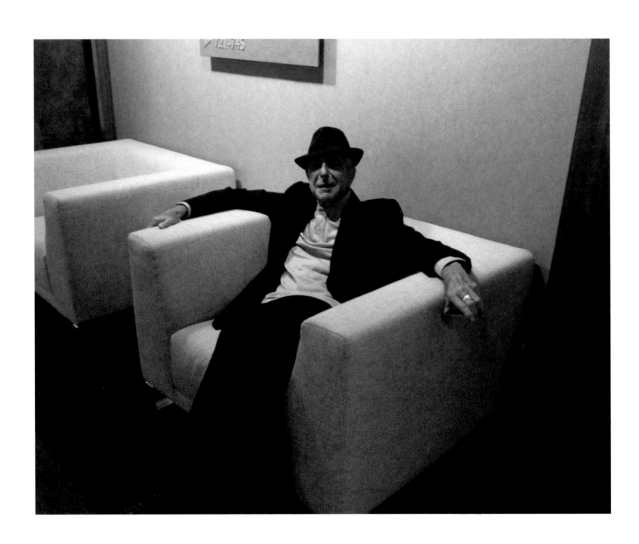

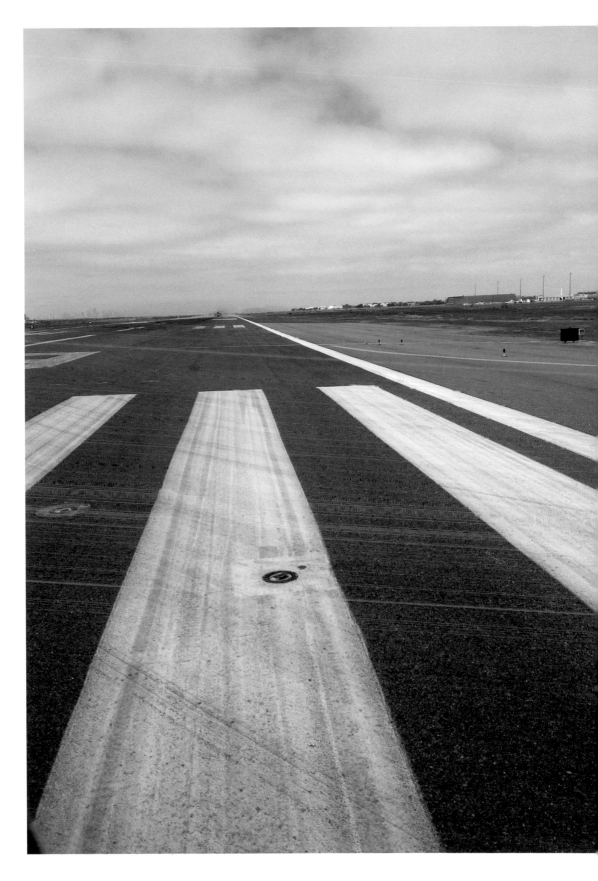

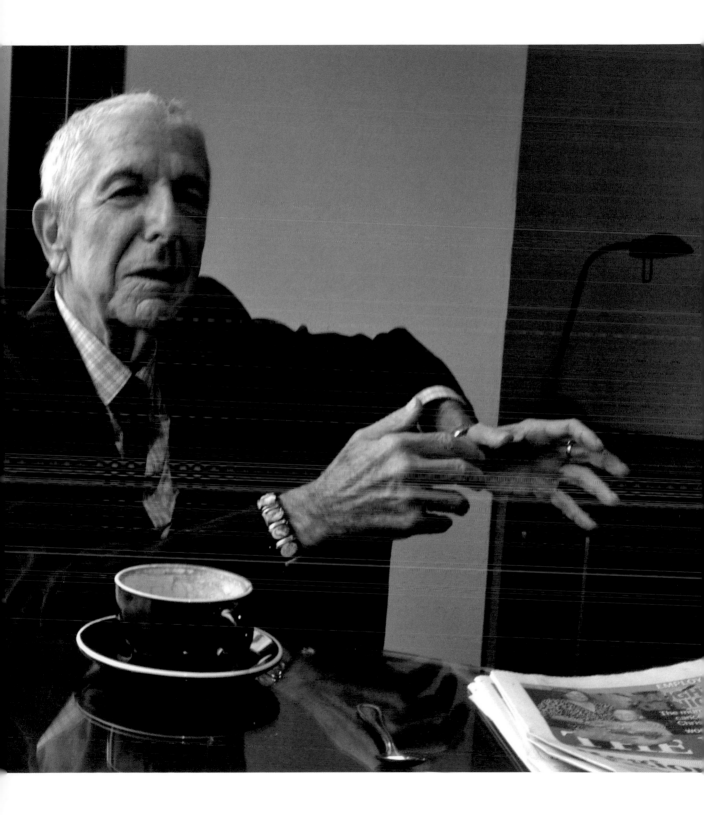

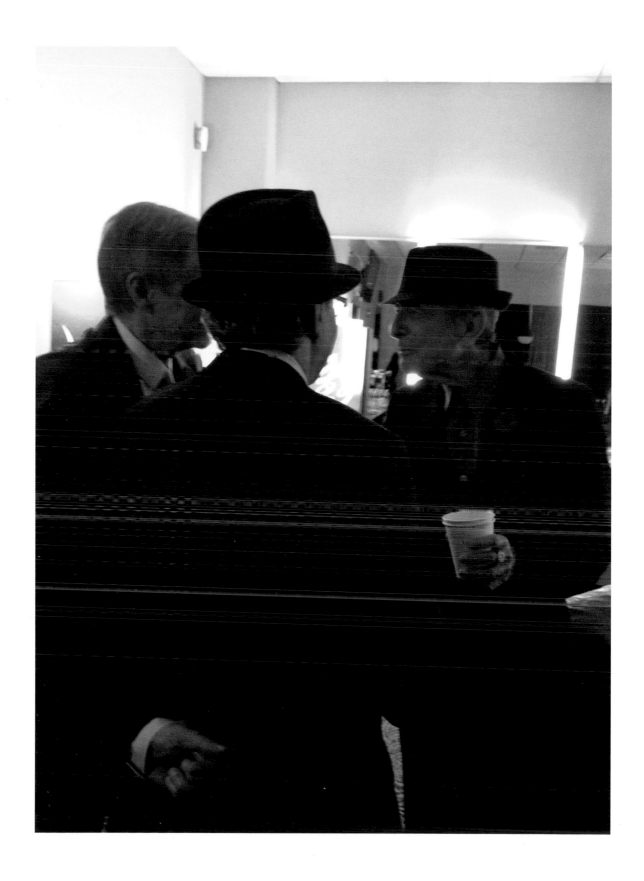

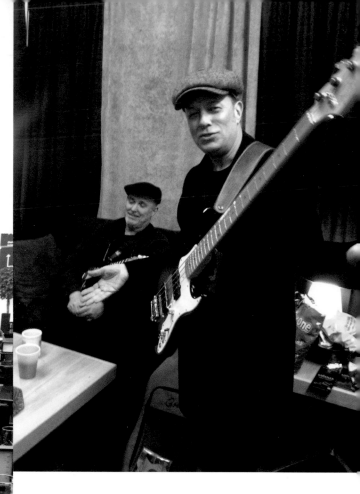

Monday	Tuesday	Wednesday	Thursday	Friday
4 mai AVEL DAY ago, Illinois	05 mai SHOW DAY Chicago Theatre - Chicago Chicago, Illinois	06 mai SHOW DAY Chicago Theatre - Chicago Chicago, Illinois	07 mai TRAVEL DAY Detroit, Michigan	08 mai TRAVEL DAY Detroit, Michiga
1 mai HOW DAY iweather Post phitheatre - bia, Maryland`	12 mai SHOW DAY Academy of Music - Philadelphia Philadelphia, Pennsylvania	13 mai TRAVEL DAY Fort Lauderdale, Florida	14 mai SHOW DAY Fort Lauderdale Private Fort Lauderdale, Florida	15 mai TRAVEL DAY New York, New Y
18 mai RAVEL DAY awa, Ontario	19 mai SHOW DAY General Motors Centre Arena - Oshawa Oshawa, Ontario	20 mai TRAVEL DAY Quebec City, Quebec	21 mai SHOW DAY Pavillon de la Jeunesse - Quebec Quebec City, Quebec	22 mai SHOW DAY K-Rock Arena Kingston Kingston, Ontar
25 mai SHOW DAY nal Arts Center - Ottawa ttawa, Ontario	26 mai SHOW DAY National Arts Center - Ottawa Ottawa, Ontario	27 mai TRAVEL DAY Boston, Massachusetts	28 mai TRAVEL DAY Boston, Massachusetts	29 mai SHOW DAY Wang Theatre - Bo Boston, Massachus
01 juin DAY OFF nver, Colorado	02 juin SHOWDAY Red Rocks Amphitheatre - Denver Denver, Colorado	03 juin TRAVEL DAY to Home		

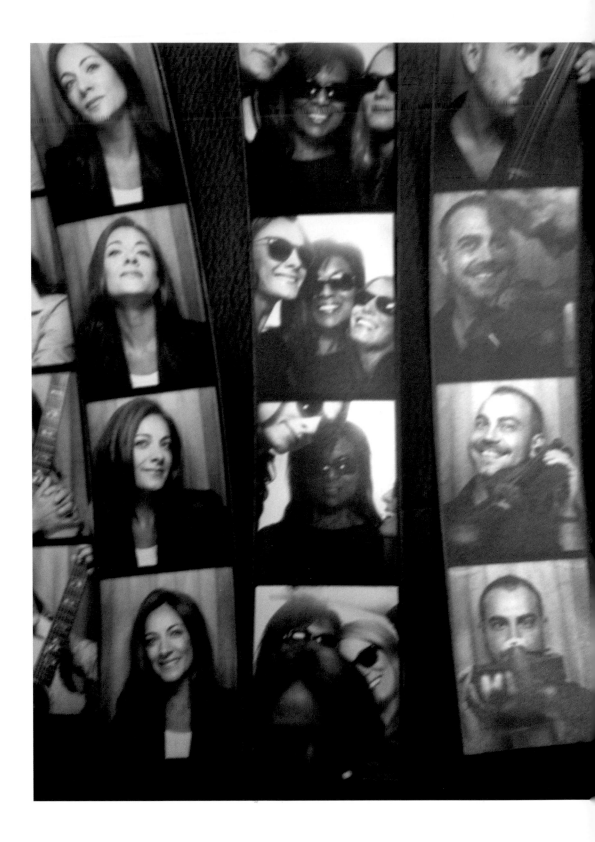

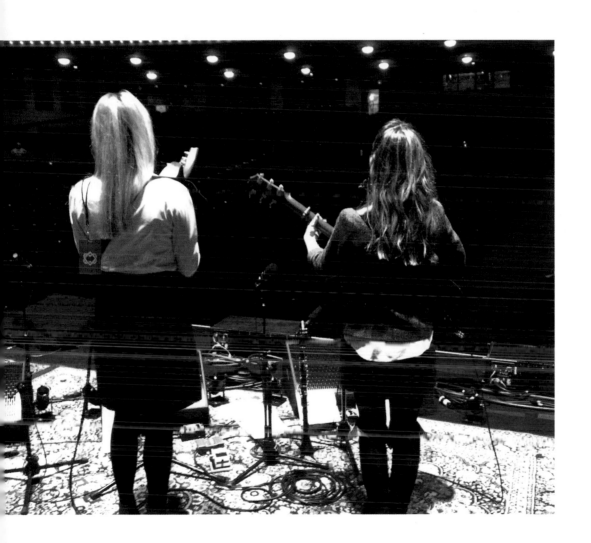

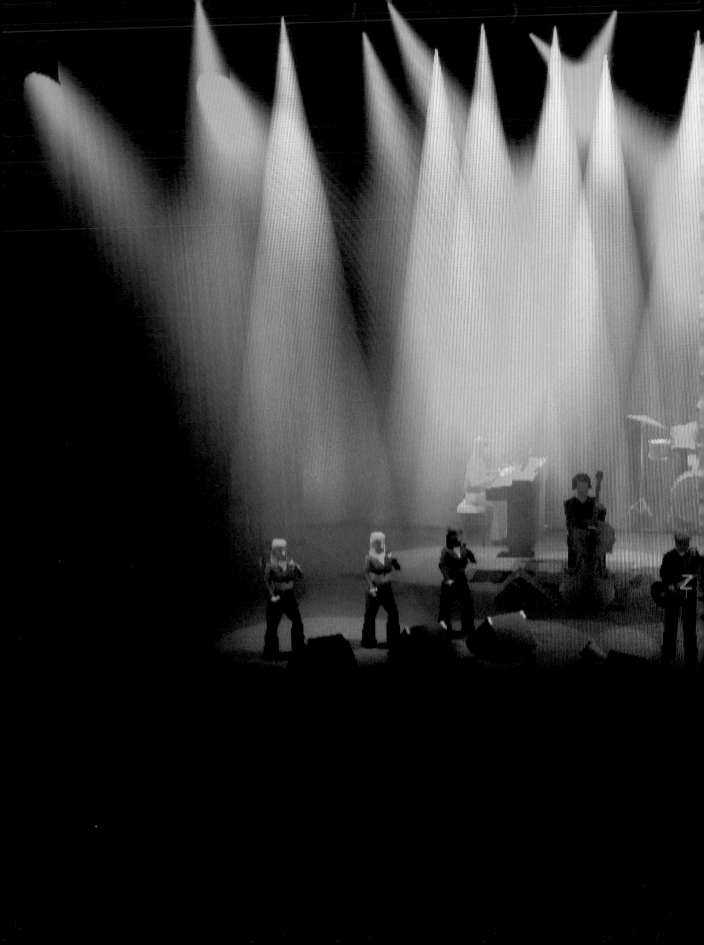

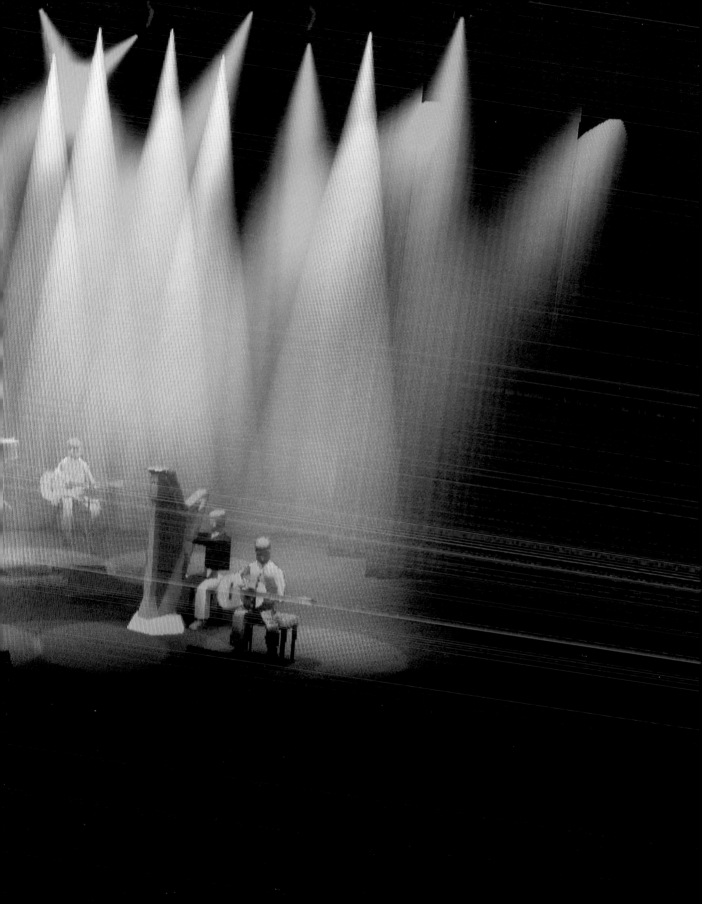

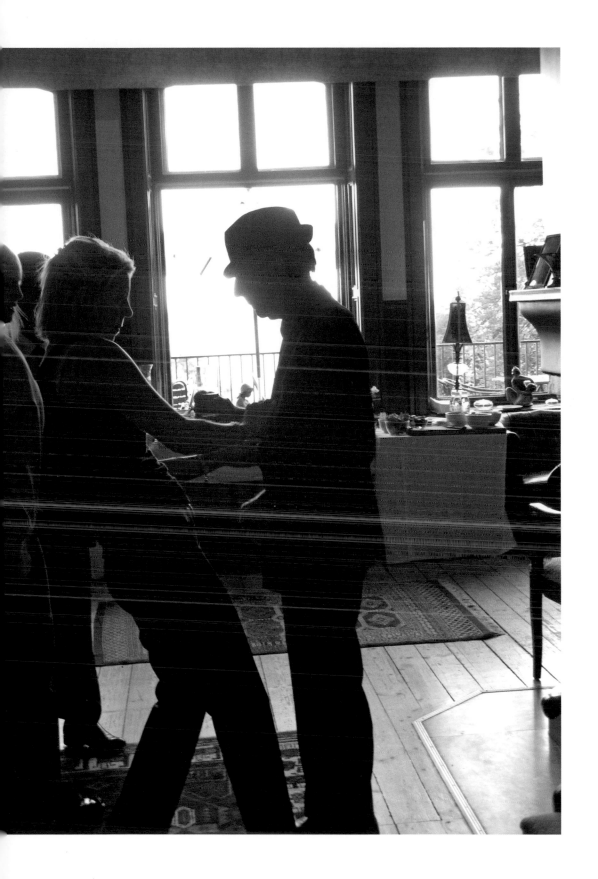

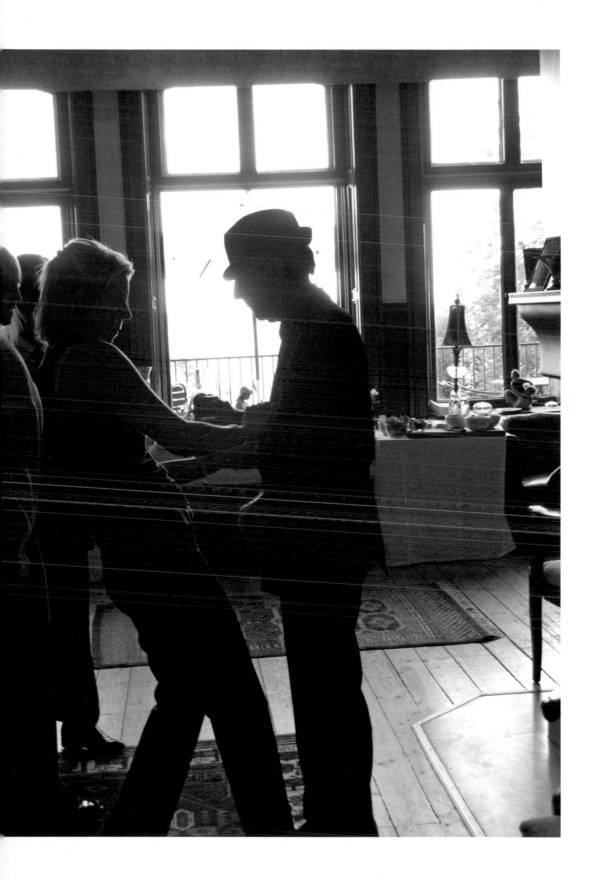

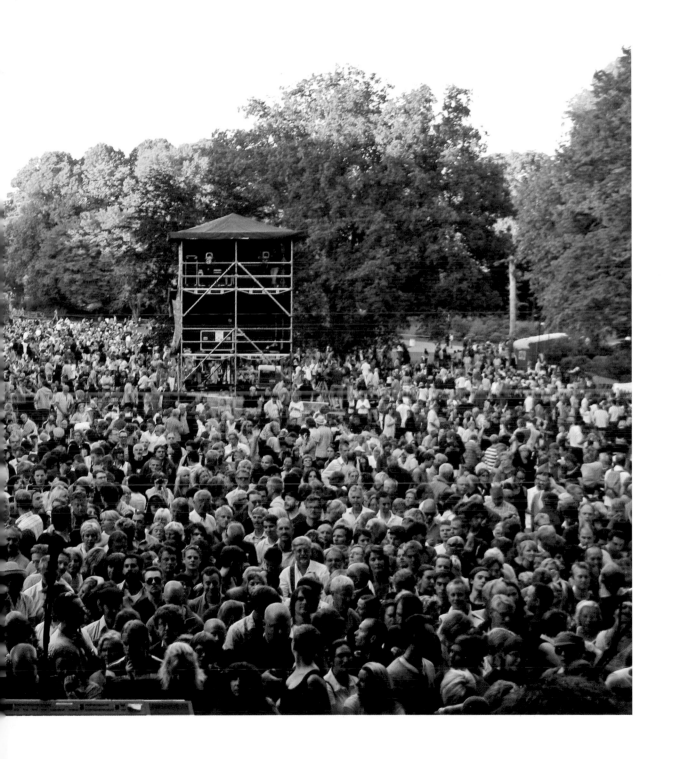

LEONARD COHEN

BERLIN

WED 17TH JULY 2013

SHOW TIMES

LUNCH:		12.30PM
LINE CHECK:		2.00PM
LC SOUNDCHECK:		3.30PM
BAND SOUNDCHECK:		4.30PM
DINNER:		5.30PM
DOORS:		6.00PM
LEONARD COHEN:	FIRST HALF	8.00 - 9.25
INTERMISSION:	20 MINS	9.25 - 9.45
LEONARD COHEN:	SECOND HALF	9.45 - 11.30

CURFEW: 11.30PM

17/07/2013

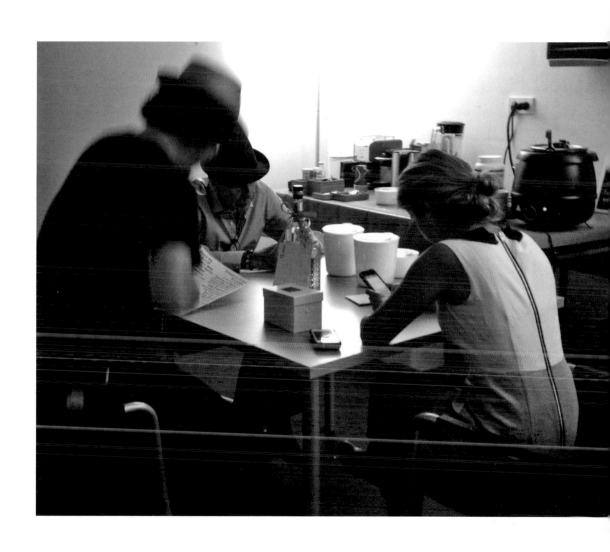

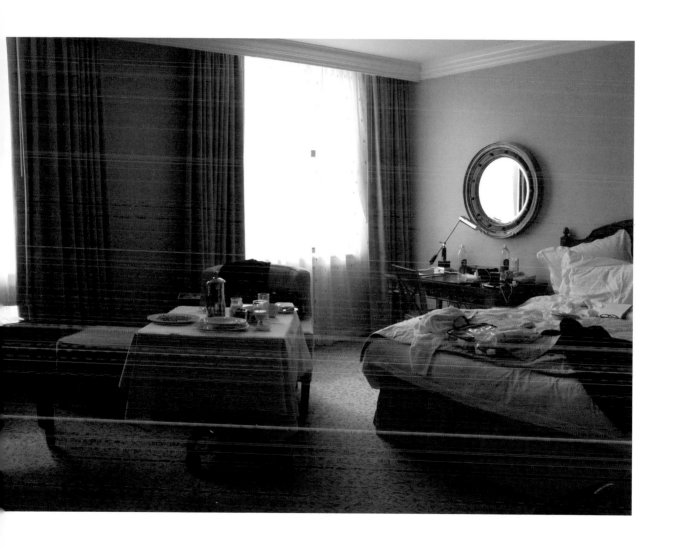

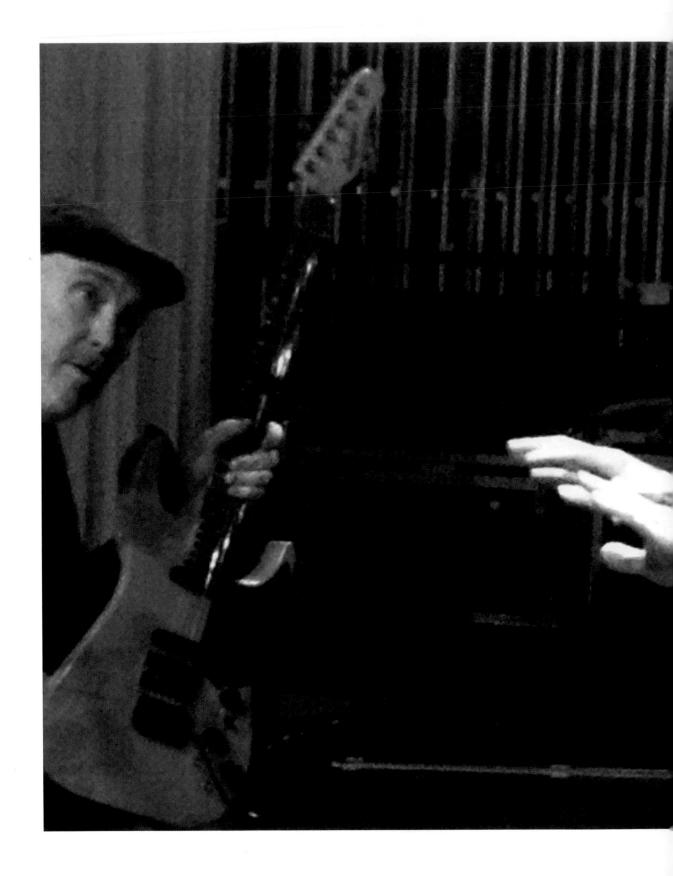

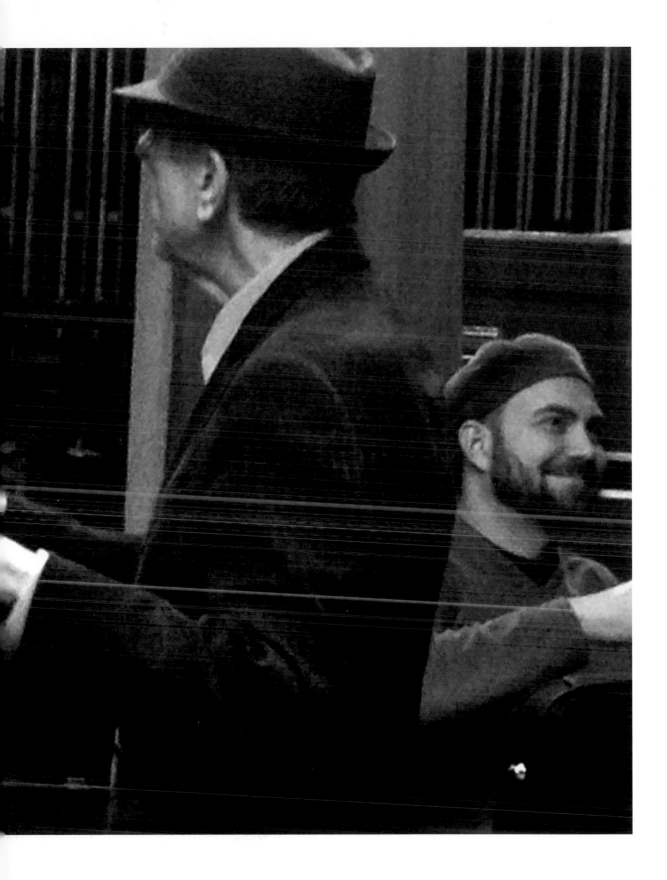

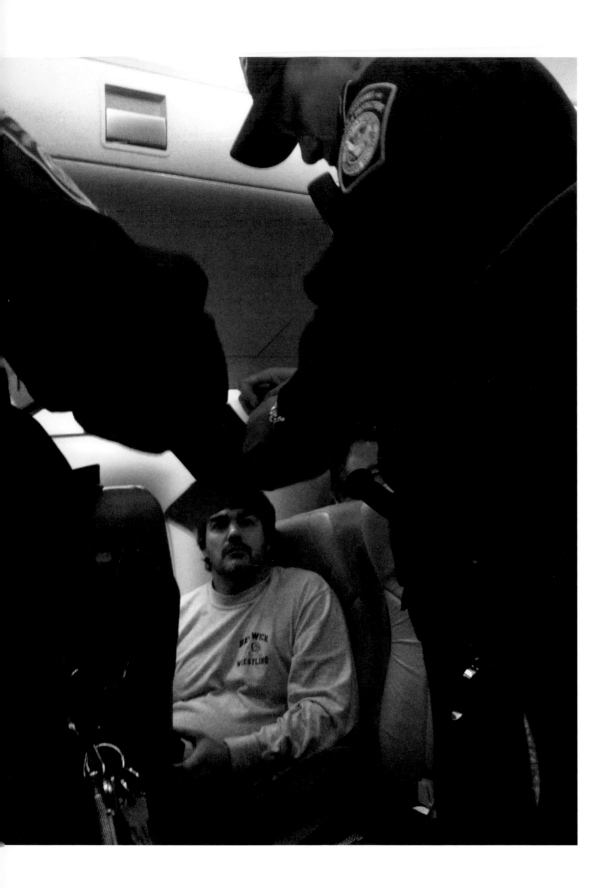

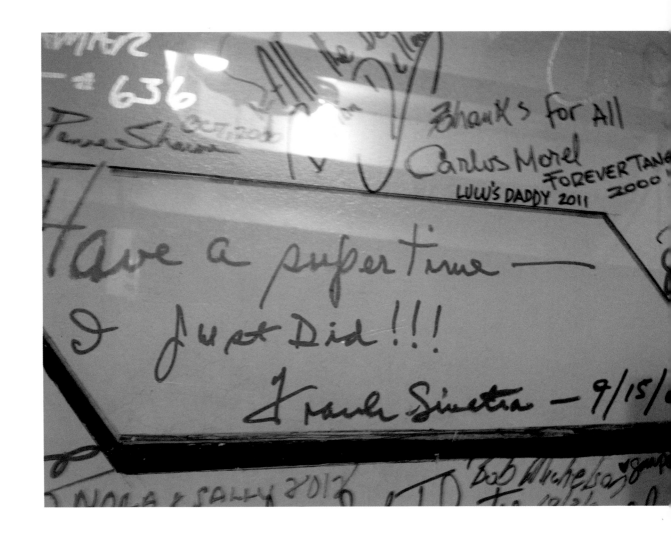

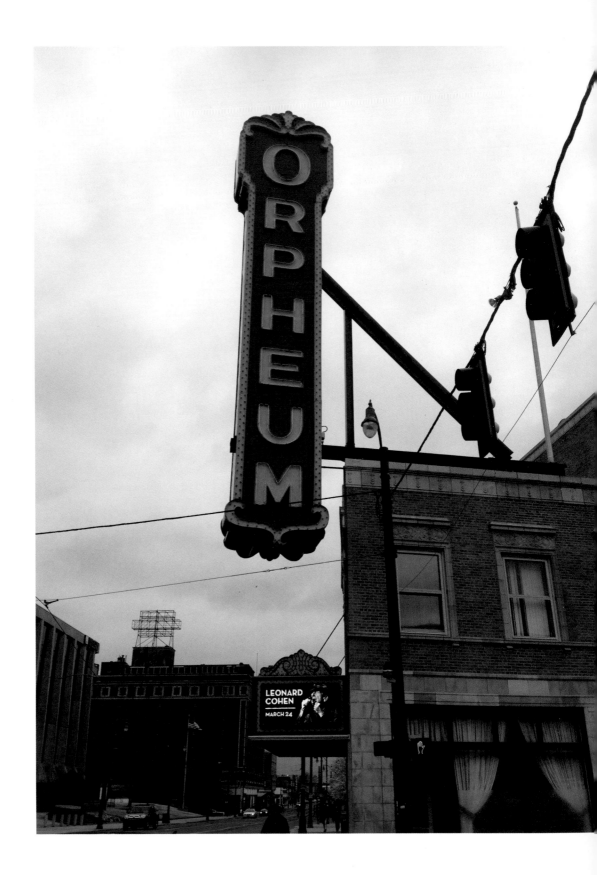

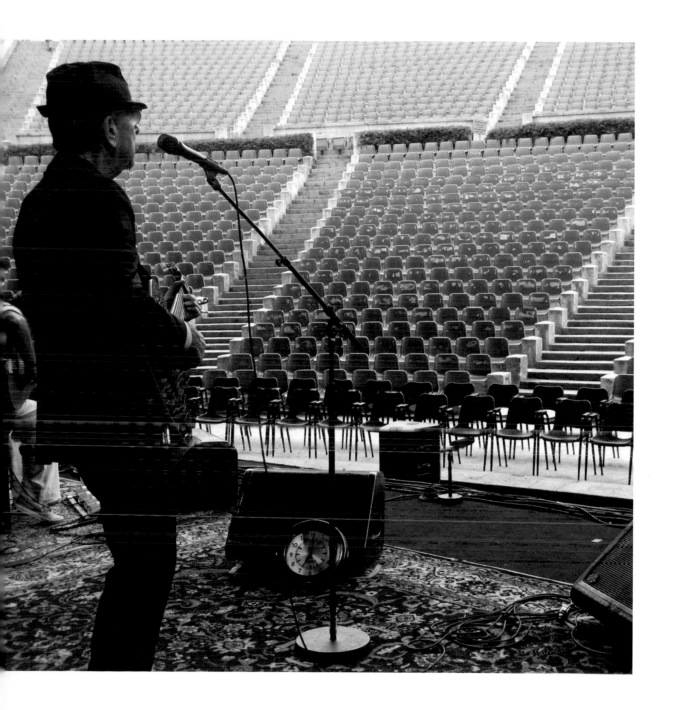

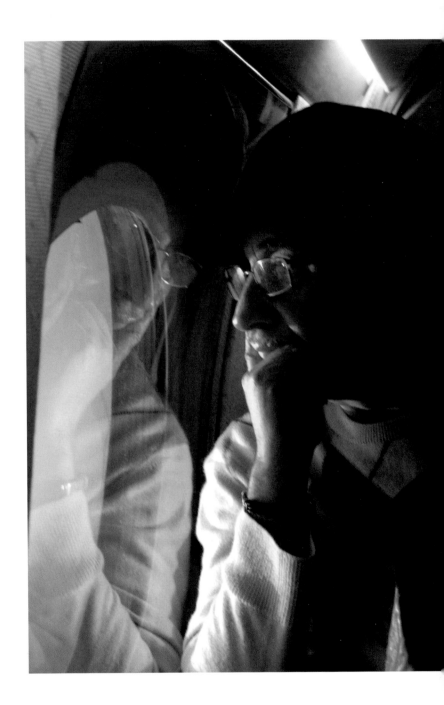

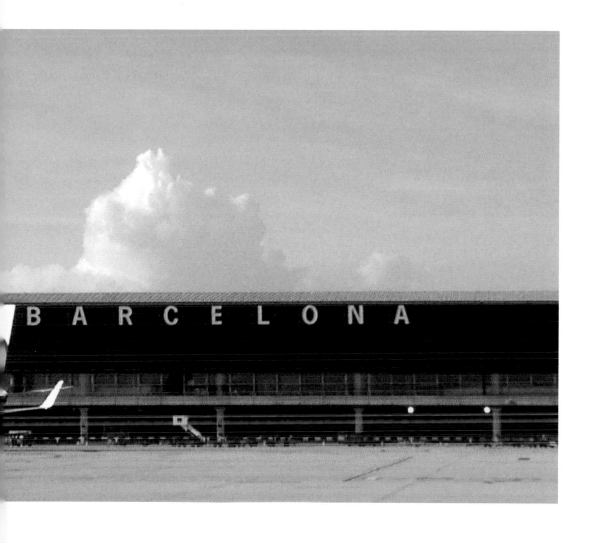

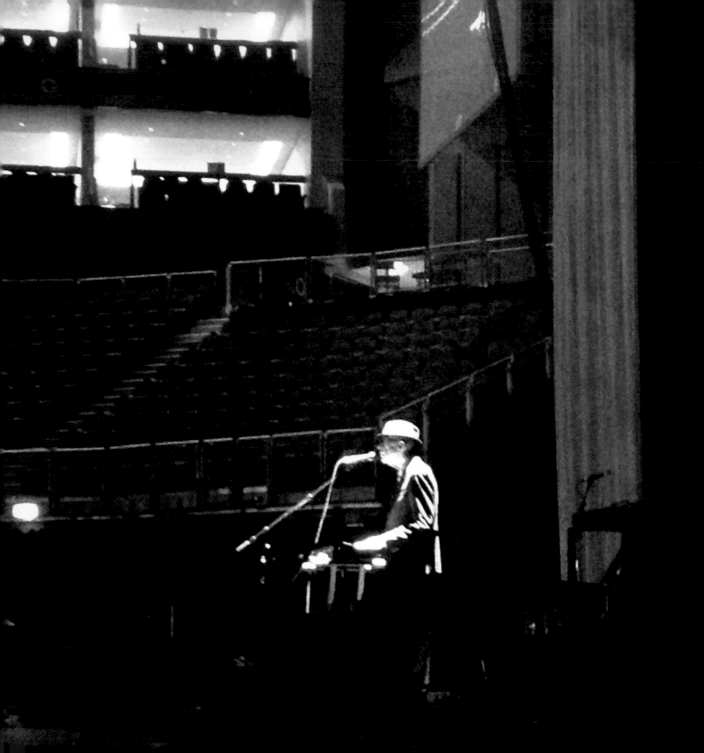

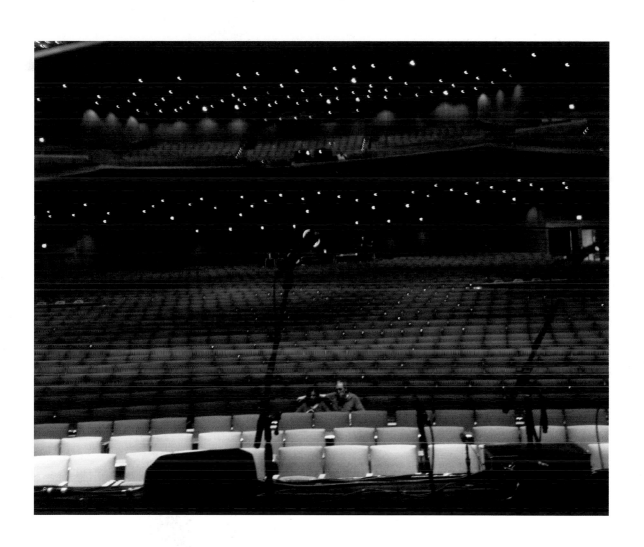

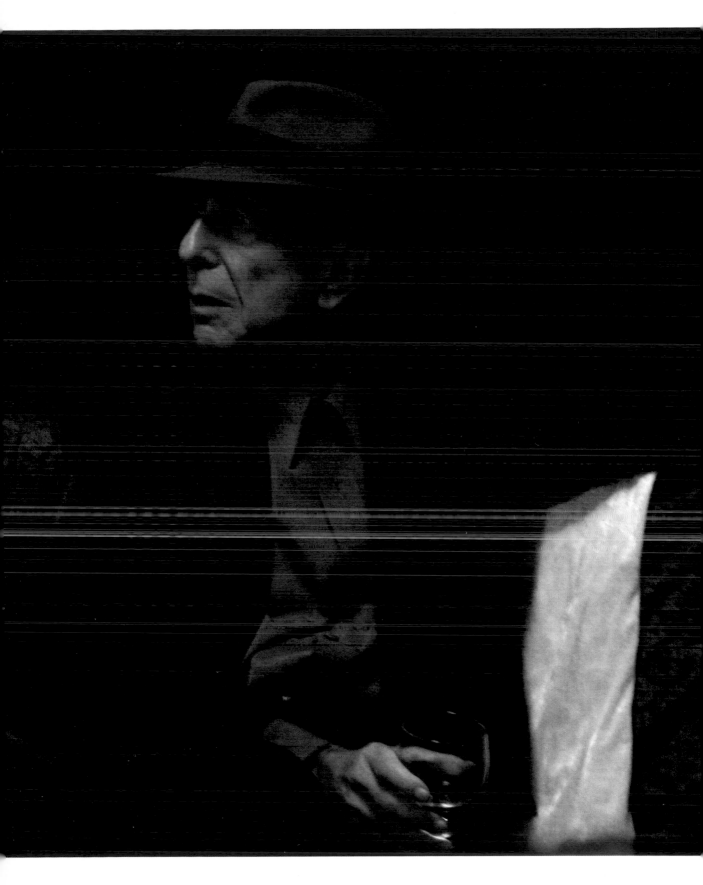

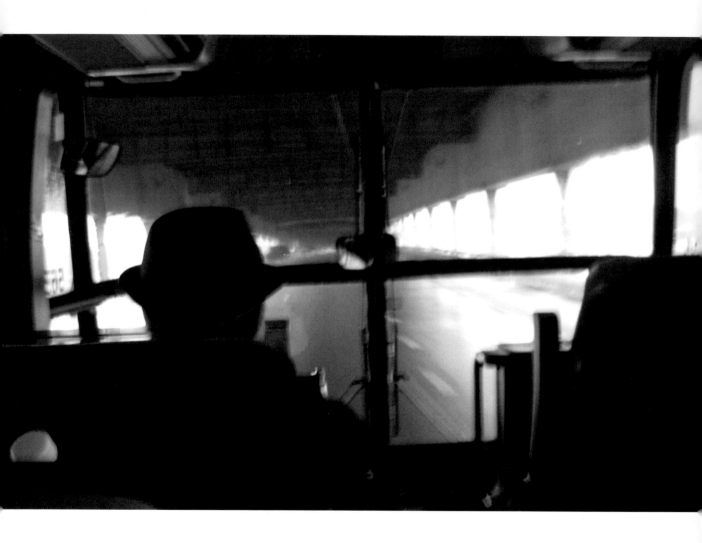

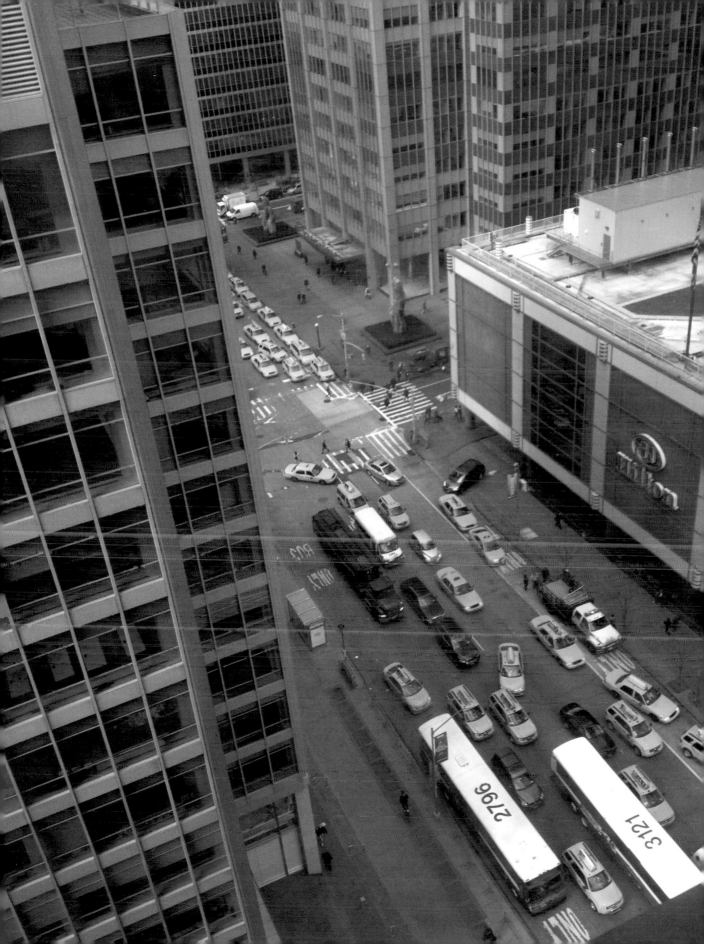

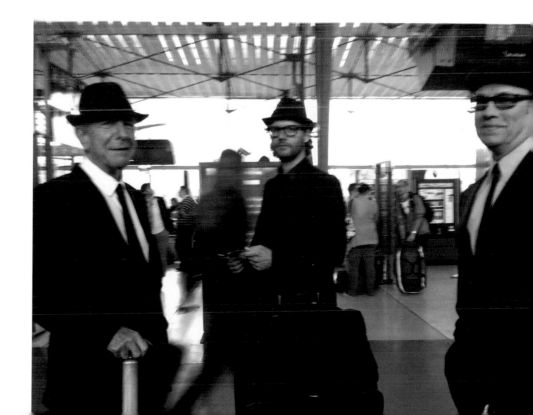

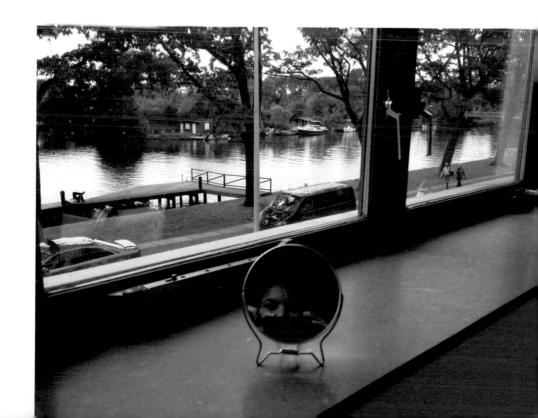

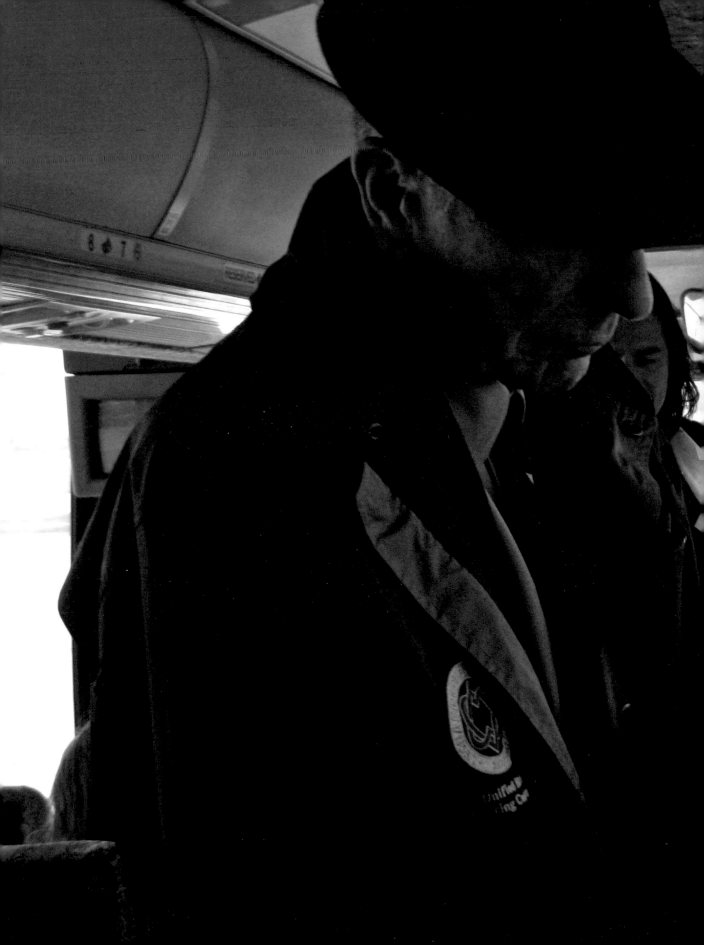

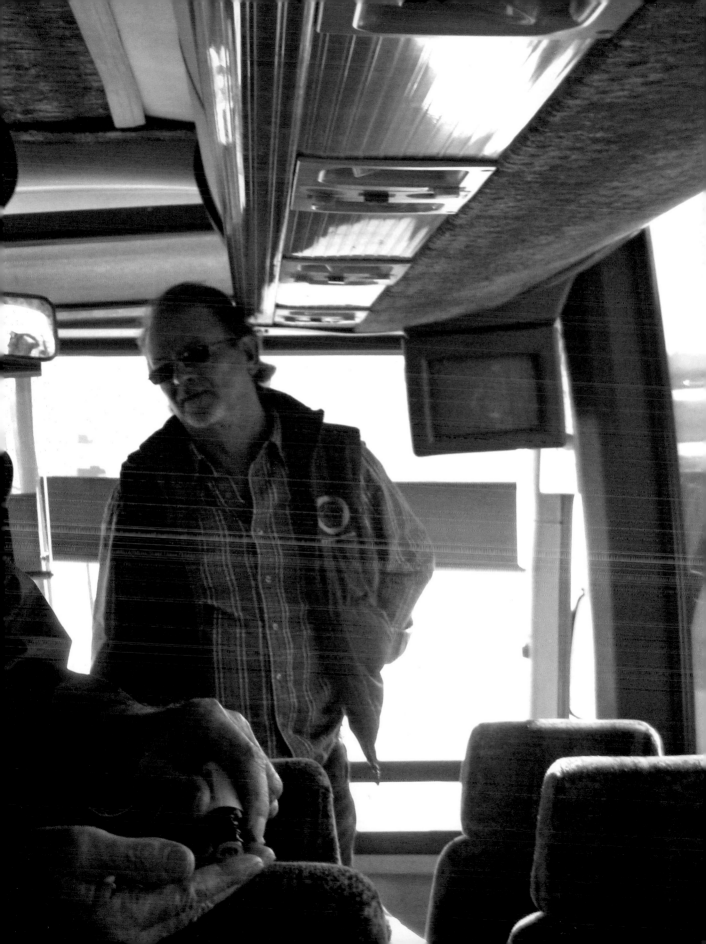

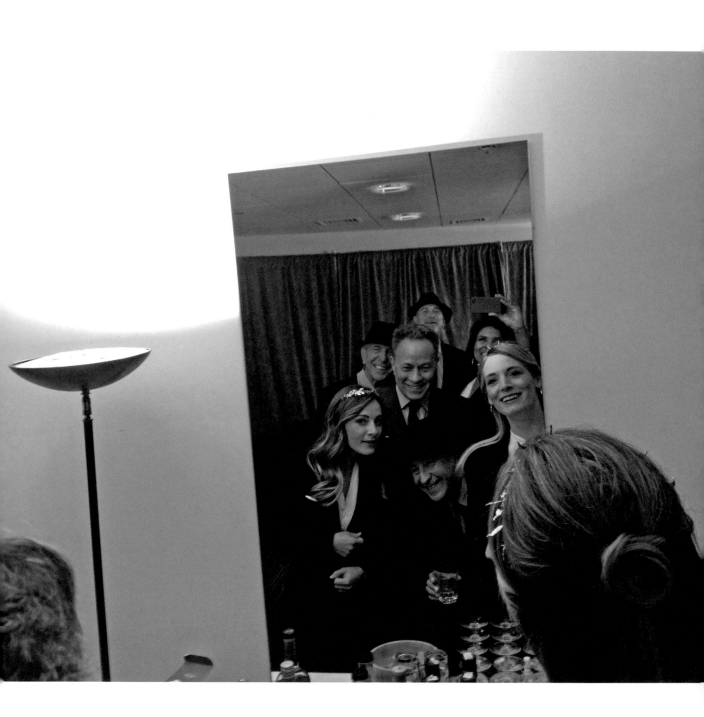

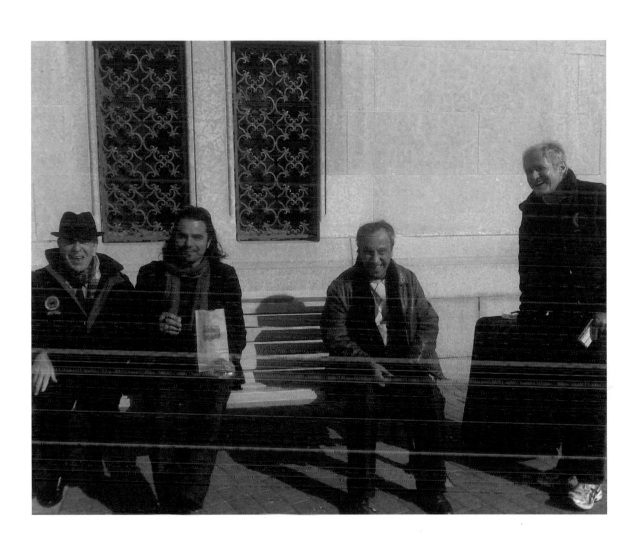

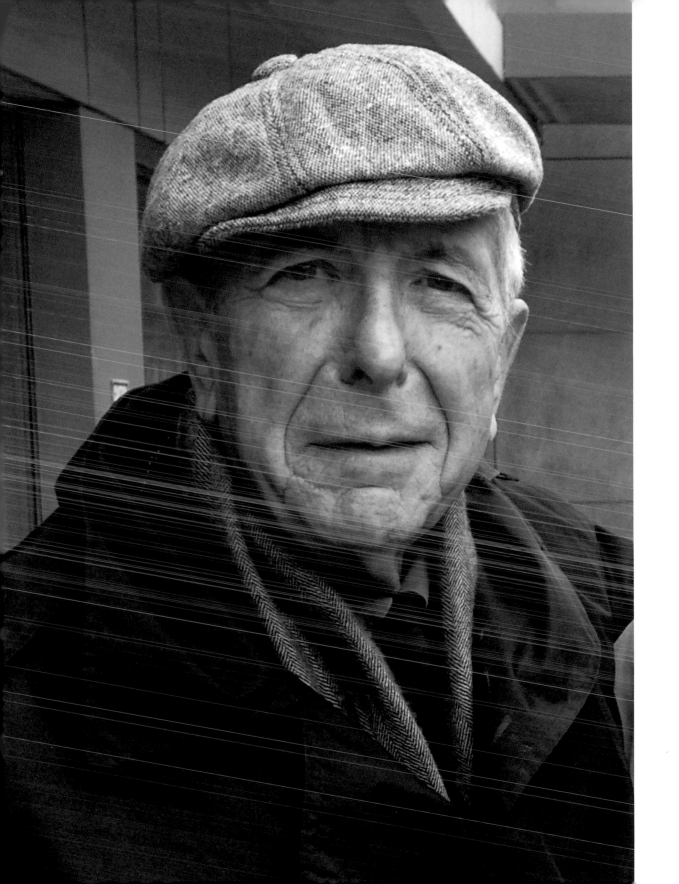

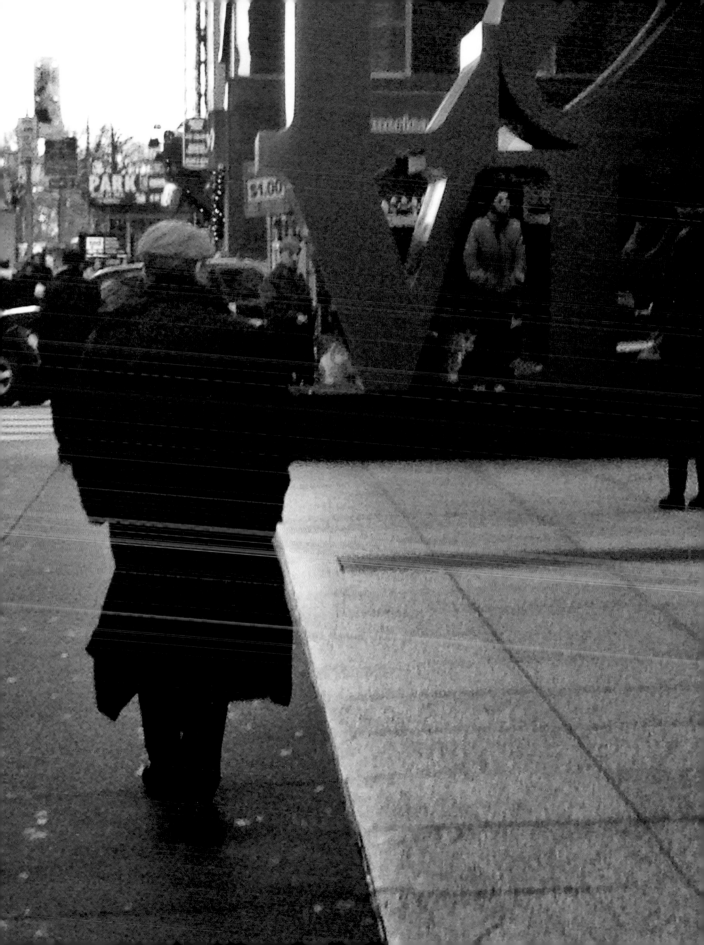

Titles & Captions

I would like to thank all those who appear in the photos:

The Band: Roscoe Beck, Mitch Watkins, Rafael Bernardo Gayol, Neil Larsen, Javier Mas, Alex Bublichi, Charley Webb, Hattie Webb, Bob Metzger, Dino Soldo, Pat Harris

The Crew: Paul Stratford, Mark Vreeken, Russell Wilson, Ryan Patrick Murphy, Dan Weingartner, Leif Bodnarchuk, Mickey Sullivan, Benni Yohl, Chris Bynum, Renee Adams, Nicky Evans, Fiona Carlisle, Natasha "Tash" deSampayo, Lyssa Bloom, Brian "Pants" Kirk, Leanne Ungar, Michelle Girmaldi

Production: Mike Scoble, Ed Sanders, Robert Kory, Lorca Cohen, Wade Perry, Joey Carenza, Kezban Ozcan, Brett Chin-Quan

Friends and Family: Jarkko Arjatsalo, Eija Arjetsalo, Tom Sakic, Dr. Heck of a Guy (Alan Showalter), Mara Larsen, Jody Lazo, Charlie Beck, Kelly Murphy, Esther Cohen, Peter Asher, Michael Gold, Jason Pipkin, Dominique Issermann, Marty Brest, Stephen Berkman

I would also like to thank: Rob Hallett, Elliott Lefko, Rodel Delfin

As photos were taken in a spontaneous manner and the book was conceived after the fact, There are many who are not in these pictures, but nevertheless were part of the magic. Thank you. I'm glad we crossed paths.

Special Thanks to:

Steve Reiss for his enthusiasm and generosity of spirit, and for pointing me in the right direction.
Greg Gold for having the idea and working tirelessly to make it happen.
Larry Sloman for his brilliant and colorful essay.
Daniel Power for his vision, confidence, and guidance.
Craig Cohen and the people at powerHouse Books for their hard work and patience.
Gustaf Törling for his extraordinary sense of design.
Stephen Berkman for his sage advice...

...and

Leonard Cohen for telling me a joke.

ON TOUR WITH LEONARD COHEN

Photographs © 2014 Sharon Robinson
Introduction © 2014 Sharon Robinson
Foreword © 2014 Larry "Ratso" Sloman

Published in the United States by powerHouse Books,
a division of powerHouse Cultural Entertainment, Inc.
37 Main Street, Brooklyn, NY 11201-1021
telephone 212.604.9074, fax 212.366.5247
e-mail: info@powerHouseBooks.com
website: www.powerHouseBooks.com

First edition, 2014

Library of Congress Control Number: 2014948291

ISBN 978-1-57687-725-8

Book concept: Greg Gold
Art Direction: Gustaf Törling
www.torling.com

Printed by Toppan Leefung Printing Ltd

10 9 8 7 6 5 4 3 2 1

Printed and bound in China

sharonrobinsonmusic.com
management: Rodel Delfin rd@rm64.com

Sharon Robinson *has been associated with Leonard Cohen for over 30 years. She cowrote, produced, and performed on Cohen's 2001 album,* Ten New Songs *(one of* Rolling Stone's *Top 100 Albums of the Decade) and toured with Leonard from 1979 – 1980 and from 2008 – 2013. A Grammy-winning songwriter, Sharon's songs have been covered by many prominent artists. Her album,* Everybody Knows*, garnered wide critical acclaim, as have her recent performances on the Leonard Cohen World Tour.*

Larry "Ratso" Sloman *is one of America's great counterculture writers and contemporary biographers. Dylan referred to Sloman's account of the 1975 Rolling Thunder Revue,* On the Road with Bob Dylan, *as "the War and Peace of Rock and Roll." He has been a friend of Leonard Cohen for 40 years.*

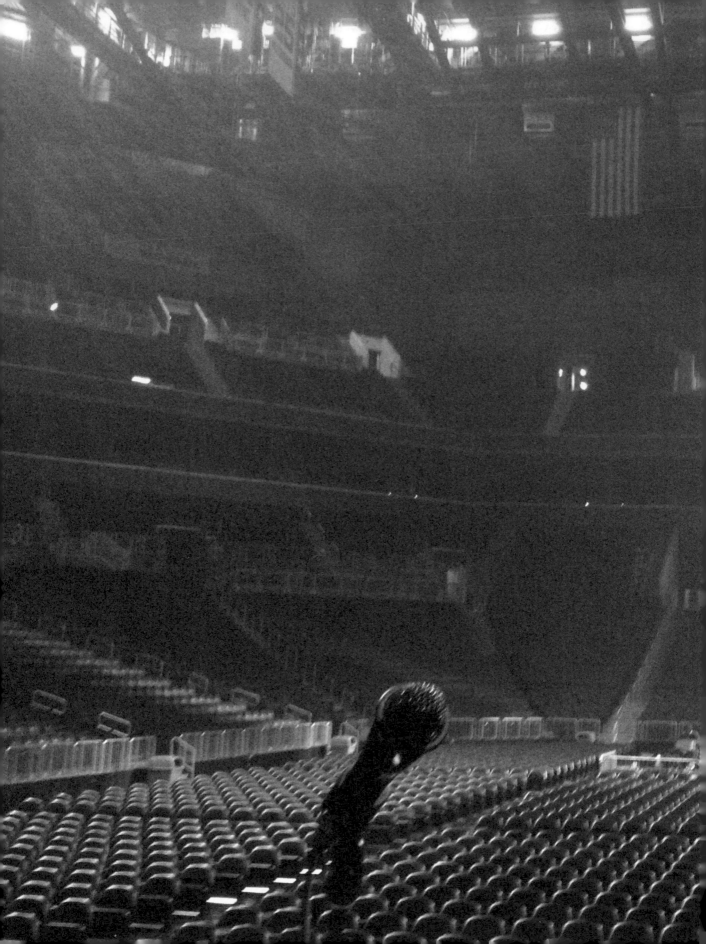